the art of

MARVEL STUDIOS

hawkeye

written by
jess harrold

foreword by
rhys thomas & bertie

cover & afterword by
rodney fuentebella

project manager
jacqueline ryan-rudolph

book design & layout by
rodolfo muraguchi

FOR MARVEL PUBLISHING

SARAH SINGER, EDITOR
JEFF YOUNGQUIST, VP OF PRODUCTION AND SPECIAL PROJECTS
ADAM DEL RE, MANAGER, SENIOR DESIGNER & ART DIRECTION
DAVID GABRIEL, VP OF PRINT & DIGITAL PUBLISHING
SVEN LARSEN, VP OF LICENSED PUBLISHING
C.B. CEBULSKI, EDITOR IN CHIEF

FOR MARVEL STUDIOS

KEVIN FEIGE, PRESIDENT
LOUIS D'ESPOSITO, CO-PRESIDENT
VICTORIA ALONSO, PRESIDENT, PHYSICAL & POST PRODUCTION, VFX, AND ANIMATION PRODUCTION
BRAD WINDERBAUM, EXECUTIVE, TELEVISION, STREAMING, & ANIMATION
RYAN MEINERDING, HEAD OF VISUAL DEVELOPMENT
ANDY PARK, DIRECTOR, VISUAL DEVELOPMENT
RODNEY FUENTEBELLA, SUPERVISOR, VISUAL DEVELOPMENT
HOLLY MYER, MANAGER, VISUAL DEVELOPMENT
KELLY BURROUGHS, VISUAL DEVELOPMENT COORDINATOR
TRINH TRAN, EXECUTIVE, PRODUCTION & DEVELOPMENT
BOJAN VUCICEVIC, MANAGER, PRODUCTION & DEVELOPMENT
TREVOR WATERSON, VICE PRESIDENT, PHYSICAL PRODUCTION
SARAH BEERS, VICE PRESIDENT, FRANCHISE CREATIVE & MARKETING
JACQUELINE RYAN-RUDOLPH, FRANCHISE STORY MANAGER
CAPRI CIULLA, FRANCHISE STORY COORDINATOR
RYAN POTTER, VICE PRESIDENT, BUSINESS AFFAIRS
NIGEL GOODWIN, COUNSEL
ERIKA DENTON, DIRECTOR, CLEARANCES
JEN WOJNAR, MANAGER, CLEARANCES
JEFF WILLIS, DIRECTOR CREDITS & ADMINISTRATION
JENNIFER GIANDALONE, MANAGER, CREDITS
RANDY McGOWAN, VICE PRESIDENT, TECHNICAL OPERATIONS
BRYAN PARKER, DIRECTOR, DIGITAL OPERATIONS
ELI HOLMES, MANAGER, DIGITAL ASSETS
DARYN HOUSTON, DIGITAL ASSET COORDINATOR
ALY GIRLING, DIGITAL ASSET COORDINATOR

ISBN 978-1-302-94585-5

PRINTED IN TURKEY

FIRST PRINTING 2023
10 9 8 7 6 5 4 3 2 1

PUBLISHED BY MARVEL WORLDWIDE, INC., A SUBSIDIARY OF MARVEL ENTERTAINMENT, LLC. OFFICE OF PUBLICATION: 1290 AVENUE OF THE AMERICAS, NEW YORK, NY, 10104..

KEVIN FEIGE, CHIEF CREATIVE OFFICER
DAN BUCKLEY, PRESIDENT, MARVEL ENTERTAINMENT
DAVID BOGART, ASSOCIATE PUBLISHER & SVP OF TALENT AFFAIRS
TOM BREVOORT, VP, EXECUTIVE EDITOR
NICK LOWE, EXECUTIVE EDITOR, VP OF CONTENT, DIGITAL PUBLISHING
ALEX MORALES, DIRECTOR OF PUBLISHING OPERATIONS
MARK ANNUNZIATO, VP OF PLANNING & FORECASTING
DAN EDINGTON, DIRECTOR OF EDITORIAL OPERATIONS
RICKEY PURDIN, DIRECTOR OF TALENT RELATIONS
JENNIFER GRÜNWALD, DIRECTOR OF PRODUCTION & SPECIAL PROJECTS
SUSAN CRESPI, PRODUCTION MANAGER
STAN LEE, CHAIRMAN EMERITUS

MANUFACTURED BETWEEN 6/2/2023 AND 8/14/2023 BY IMAK OFFSET, ESENYURT, ISTANBUL, TURKEY.

contents

FUENTEBELLA ▶

In Hawkeye's first five appearances in the Marvel Cinematic Universe, he went from being a S.H.I.E.L.D. agent to a founding Avenger and helped save the world multiple times. But after those films, how well did we really know Clint Barton? Not nearly enough, as far as actor Jeremy Renner is concerned. When it comes to fully getting inside his character's head, he's had to be patient. Marvel Studios' *Thor*, as he puts it, was "a quick cameo thing" and then, in *Marvel's The Avengers*, just as he was "still trying to figure this guy out," Clint became mind-controlled as "Loki's sidekick" for much of the film. "Like, hey, guess what, boop—you're not Hawkeye," Renner says.

Marvel Studios' *Avengers: Age of Ultron*, which introduced Hawkeye's Iowa ranch, where he lives with his wife, Laura, and their children, was a major step forward. "When they cemented the family life, I think that was a huge thing," he says. "Having that secret family and grounding it to his real values, that was a great leap for the character." The seismic events of Thanos' Snap, which cost Clint his loved ones for five years, sent him down a dark path as the murderous vigilante Ronin, as shown in Marvel Studios' *Avengers: Endgame*. But with his family back along with the billions of other returnees of the Blip, Hawkeye has been able to rebuild his life, albeit still bearing the scars of that experience—and mourning the death of his best friend, Natasha Romanoff, the Black Widow. Now, at last, in his own Disney+ series, Renner gets to mine all that emotional material and really show what makes Clint tick.

"Finally getting to spend a lot of time with him was a big learning process for me, because a lot of stuff is going on in this show, there was a lot for me to learn," he says. "I remember having a video call with all the brass and everybody and I'm like, guys, I think in the first two weeks of shooting this, I've said more than I've said the entire MCU thus far." Renner enjoyed the process of finding Hawkeye's voice—and his sense of humor—across six episodes, comprising over four hours of story. "It's been a wonderful way to just really dig and discover a lot more of the humanity of who Clint Barton is. And I'm very blessed for that."

Executive Producer Trinh Tran agrees that "it is about time that we're telling Hawkeye's story." Tranh says, "What really intrigued me about Clint Barton and his journey is that he is a Super Hero without any super-powers. And he's standing next to gods. But this guy is just like me and you. He is, I think, one of the most relatable Avengers in the MCU, and I wanted to really explore that groundedness." In addition, she was excited to introduce Kate Bishop, the young female version of Hawkeye from the comics, played here by Hailee Steinfeld. Adding Kate into the mix meant that Marvel Studios' *Hawkeye* could explore the mentor/mentee relationship between the two of them and put the focus on the more fun side of Clint Barton, well-known to comic book readers, but so far only really hinted at in the Marvel Cinematic Universe. Faced with "so much great source material" to draw from, Tranh's big question, as she initially contemplated a potential Hawkeye movie, was: "How am I going to actually put this all in two hours?" Thankfully, Marvel Studios' move into streaming on Disney+ opened up exciting new possibilities. "We thought, well, if there's a lot more story to tell about these two Hawkeyes, why not just move that project over to Disney+, so that we can explore how those two characters really come together and also tell a little bit of Clint's history and how he became who he is?" Tranh cites one particular Marvel Comics run—writer Matt Fraction and artist David Aja's award-winning collaboration on the 2012 *Hawkeye* series—as being influential. "It is really amazing," Tranh says, "because it showcased a Clint Barton who's maybe a little bit more irresponsible. In a way, Kate mentors him sometimes. So, there is a fun dynamic between the two of them where the mentor and mentee relationship sort of switches around every now and then. They're like an older brother and a younger sister, constantly bickering. But they have such a mutual bond and affection towards one another."

Renner enjoyed the developing kinship between his established Avenger and this brilliant young archer—and would-be Super Hero—that lies at the heart of the show. "He begrudgingly has her as a partner, and then their friendship grows," he says. "I think he sees a lot in her. I mean, first, she's a real pain in the butt and then becomes a real problem, but then he learns to really have a lot of respect and adoration for her. Their relationship shifts dramatically from 'I can't stand this kid' to 'wow, now I want to take care of this kid forever.'"

And all of that happens over the course of a week—because it's late December in the Big Apple, and Hawkeye has seven days to make it back to his family for the holidays. The only things standing in his way are a would-be vigilante in his old Ronin suit, Kate's overprotective mother, a rich guy with a penchant for swords, an army of mobsters in tracksuits, two deadly martial artists, each out for revenge for their own reasons, and the most dangerous man in New York City. Clint Barton will be home for Christmas—even if it kills him.

Well, this is exciting. A book that will give you an insight into some of the incredible artistry that went into making and crafting this soulful, funny, and dynamic show.

There are a few key words that come to mind when we think about Hawkeye. *Fallibility* is one of them. One of the core themes of Matt Fraction and David Aja's *Hawkeye* comics. All those Band-Aids and bruises. It's super funny but also reminds us of Kate and Clint's humanity at each turn. Fraction and Aja's comics very quickly became the blueprint for the show—the irreverent tone, the goofiness, and the rules of the world—in so many ways.

Being flawed and human is such a Hawkeye trait. Unlike Thor, the Hulk, Wanda, all those superhuman Super Heroes who zoom around with their powers, Hawkeye has always had to rely on himself, his human talent, and his ability to just stay the hell alive! And our heroes literally wore their battles on their faces (thanks to our make-up department, helmed by Dennis Liddiard).

Hawkeye's inherent fallibility and humanness drove so many of the decisions we made creating this world. We were all excited to skirt the bountiful line between a grounded and gritty New York City, in which we believed our heroes would have to fight for their lives, and a slightly heightened world, just enough so that we could believe anything was and is possible—like trick arrows!

While we're talking about trick arrows, you are going to see some of the incredible work of Russell Bobbitt, our property master, who is a Marvel legend. Meetings with Russell are like adventures into an infinite cabinet of Marvel creativity. Sometimes we'd come up with crazy ideas for arrows and Russell would come back with designs that would elevate the concept but always felt in keeping with this real world we were striving for.

I remember when we were deep in planning the epic car chase for Episode 3 and we were discussing some of the wild things we wanted to do and how we could make it feel real and grounded. There had been a lot of discussion about doing the "oner" on a blue screen stage and adding the world around the car in post. I'll never forget, it was actually our wonderful VFX supervisor, Greg Steele (who you might have assumed would always come up with a VFX solution to any challenge). Well, no; he sidled up to me one day on a scout and said, "You know the car oner, if you want to make it feel real, you should do it for real." And he was right—that was the philosophy of the show, after all, and it made perfect sense. From that moment on, we

put all our efforts into planning, practicing, and doing that car sequence all outside, all for real, with only the bare minimum of VFX added. Best decision ever.

Without our cinematographer James Whitaker and his team, that car scene would never have come to life with such class, creativity, and technical excellence. James pushed the visual bar at every turn. *Hawkeye* wasn't a TV show to us, it was a six-hour movie cut into pieces, and James understood this and ensured we kept the cinematic bar high while keeping the characters, story, and emotion front and center.

It was this constant dance between realism and spectacle that made *Hawkeye* such a fun sandbox to play in. Our wonderful production designer Maya Shimoguchi worked tirelessly to ensure it felt like the New York we all know and love, with all its dirt and texture, but also to add playful touches wherever possible. This is a world built as much for a curmudgeonly Clint Barton as it is for the larger-than-life LARPers, the dangerous Maya Lopez, and, of course, wide-eyed trainee hero Kate Bishop.

Costume Designer Michael Crow is, of course, no stranger to Marvel and extreme Super Hero outfits, but I think the challenge here was to move between our two worlds of everyday New York and ass-kicking Hawkeye escapades. The wardrobe did this beautifully. Everything was possible. Kate's makeshift hero costume was pitch perfect. The Tracksuit Mafia managed to be intimidating but also hilarious at the same time.

And then there was the *absurdity*. The world of *Hawkeye* had to feel like a place where Kate could deal with the tragic loss of her father and a world in which Clint could legitimately fear for the safety of his family. But it's also a place where trick arrows can grow to obscene proportions and where Hawkeye must faux-fight LARPers to retrieve his Ronin suit. Absurdity and moments of silliness are really what give the show its unique edge and flare.

To this end, we wanted to push the world where we could with little touches of mischievousness, like the kiddie rides in the toy store, an inflatable dancing Santa popping up in the car chase, and hot sauce in Kate and Yelena's mac-and-cheese scene.

The holidays! Let's face it, Christmas is another character in the show. But not just the glitzy, glamorous festivities of bygone eras. *Hawkeye* often celebrates an irreverent take on the holidays—a loving homage to "tacky Christmas," "lonely Christmas," or, as Shimoguchi used to call it, "sad Christmas."

Nowhere did we get to play with this more than in Episode 4 when Kate brings a small but thoughtful seasonal celebration to Clint at Moira's apartment. Movies, pizza, bad decorations, frozen margarita mix. It's both incredibly funny and deeply touching, and it's in moments like this that the show is at its best: reminding us that family is whomever and wherever we choose it to be. Surrounded by the warmth and coziness of the odd '70s treasure trove of Moira's eclectic apartment, Clint and Kate seal the bond of their friendship.

And all this leads us to *heart*. I think this is why people really gravitated to the show and what kept fans coming back week in and week out. *Hawkeye* has so much heart and soul. The emotion is never lost in the art of the world. In fact, the way everyone worked so hard to ground this piece is what allowed the character relationships to really shine through.

The detail in the sets was off the charts. Our set dec Missy Parker poured heart and soul into every inch. Each location told the story of a character. Maya's apartment was a deep well of sketches and paintings and collected items from her father and from her student years. It shows a creative soul who had her whole life before her but then got derailed by a tragic event and consumed by obsession and the need for revenge. I remember Alaqua entering her apartment for the first time and being blown away. She spent ages just touching items, getting to know it, getting to know her character more deeply. That's what world creation and depth can give to an actor.

Likewise, Kate's apartment was deep and richly layered. It told us so much about her: her passions, how she spent her time. And after the fire, it had this real sense of melancholy, which was perfect for Episode 5: Kate Bishop, alone, at her lowest, walking in the door of a place she'd made her life. It felt so deeply moving. Her dreams of being a hero had been literally burnt to the ground. Little did she know that one of the most iconic meetings of young female Marvel heroes was about to take place.

So, enjoy. You're about to peruse some of the incredible artists' work that went into making this show. I hope you relish browsing these pages as much as we enjoyed creating the series at the time. I think you really feel it when a bunch of talented people have a great time making a show, and *Hawkeye* is a shining example of that! Have fun.

Bertie
x
Bertie

I'm going to come clean and admit right here, right now, that I was only the most casual of comic-book browsers growing up. I'd enjoy the odd issue of this or that but never truly fell in with a character to the extent that I could call myself a fan. That all changed when a friend recommended that I check out Matt Fraction and David Aja's *Hawkeye*. I know, that's late.

Everything about it cut directly to my sensibility. The art draws you in immediately because it's so cinematic, but then you combine it (perfectly, by the way) with a tone in the writing that is so human that you can't help but fall in love. The character of Clint Barton is so well defined. The beauty of the Fraction and Aja run, for me, is the way in which they paint a tragic character in Clint but then use the world around him to stop him from wallowing in it. Kate Bishop, of course, is the most aware and empathetic part of this world, and it's Clint's connection with her that pulls him through. Along the way, they find themselves in both high-stakes and low-stakes situations, but that's almost beside the point. The joy is in the fact that we learn that Clint's curse is that he'll tackle these moments with the same zeal no matter what. He's a man resigned to the absurd inevitability of his life—a hero who doesn't feel like one.

In the Marvel Cinematic Universe, Clint has, of course, charted a similar path. His humanity has always been present in the form of his family, and we've been able to put ourselves in his shoes as we've watched him groan with both physical and emotional pain while individuals of godlike power do their very best to stop him. When we left him in *Endgame*, he had been on a brutal journey, having brought back his family at the cost of losing his best friend. We knew that he felt he didn't deserve this salvation. What a starting place to have for a character! As you can imagine, the prospect of taking the complexities and demons of the MCU's Clint and working them out through the wryly absurd lens of Fraction and Aja's *Hawkeye* was incredibly exciting. We join him as he is trying to take a moment to enjoy Christmas with his kids—a wonderfully mundane and relatable desire. What could go wrong? Well, if you're Clint Barton, a lot. Enter Kate Bishop, Clint's biggest fan. Initially, it appears her energy is at complete odds with

Clint's—she's the fan who's modeled herself on the Super Hero who he doesn't feel he is. However, what I enjoy about the Fraction/Aja iteration of Kate, which we try to filter through the MCU lens, is that she does actually have her own darkness walled up inside. While the surface qualities of her youth and energy provide a fun contrast with Clint's, it's the way in which she has dealt with hurt at such a young age that gives the character compelling depth. It might appear that Clint's responsibility is to mentor her and teach her maturity, yet in reality, we know, as an audience, that she feels just as responsible for him. This is where we see them meet as equals—the fun, of course, lying in the fact that neither would ever admit the other is equal.

Just as Fraction and Aja did not produce their unforgettable saga of Clint and Kate in isolation—so much credit for the success of their *Hawkeye* should also go to colorist Matt Hollingsworth, letterer Chris Eliopoulos (with Clayton Cowles), guest artists Javier Pulido, Steve Lieber and Jesse Hamm, Francesco Francavilla, and Annie Wu, as well as the many talented editors of Marvel Comics—so too am I indebted to an army of brilliantly creative people whose collective vision brought these characters to the screen in Marvel Studios' *Hawkeye*.

I was brought onto this project by Trinh Tran, whose enthusiasm and knowledge of all things Marvel made me feel like I was in incredibly safe hands throughout. Safe hands like Kevin Feige, Victoria Alonso, and Louis D'Esposito, who are so, so important yet welcome you like you're part of the family. Our production team, led by Leeann Stonebreaker, Nadia Paine, and Christie Kwan, who built and maintained the scaffolding on which our show emerged. The incredible visual development team, led by Rodney Fuentebella, who opened the door to imagining what the world of our show might look like and gave me the incredible, dream-fulfilling opportunity to actually shape real-life Super Hero costumes. Michael Crow, our amazing costume designer, who actually made those costumes happen and helped bring our characters to life. Sarah Finn and Jason Stamey, who helped build our incredible cast. Maya Shimoguchi, our wonderful production designer, who calmly accepted the challenge of not only

re-creating Rockefeller Plaza in Atlanta but also whipped up a Broadway show like it was nothing. Todd Harris, our lead storyboard artist, who helped me think bigger. The incredible Greg Steele and David Bosco, our VFX supervisor and producer respectively, who held my hand and always encouraged me to think even bigger. The team at The Third Floor, led by Paul Berry, who made me think even, even bigger. The indomitable Heidi Moneymaker and her stunt team, who, for want of a better phrase, kicked ass with a smile every single day. Eric Steelberg, my DoP, who understood the assignment of helping us ground this show in reality and made everything look beautiful. Doug Plasse, my first AD and on-set raconteur, who kept everyone smiling when the temperatures dropped. Tim Roche, Terel Gibson, and Rosanne Tan, our editors, who worked like sculptors, helping us deliver the tone we wanted. Of course, Bert and Bertie, my partners in crime, who directed three beautiful episodes. Marc Shaiman! *Rogers: The Musical!* Need I say more? There are so many more people, and I know the book editors are already feeling stressed by my word count. I'll end with our cast, anchored by the incredible Jeremy Renner and Hailee Steinfeld—the show is nothing without them. The characters are nothing without them. Thank you.

This book celebrates the artistry of all those involved in placing Clint Barton center stage in a six-part genre movie he had no desire to star in. It's like a wounded John McClane stumbling into *Knives Out* and finding out the door has locked behind him. The clash of tones—from Super Hero to buddy comedy to family drama to slice of life—is really dear to my heart. The fact that we're using this bricolage to bring one character closer to retirement, while setting another out on their journey of adventure, felt like the perfect way to tell the story of the MCU's most human Avenger.

Rhys Thomas

meet your heroes

In Episode 1, we are introduced to Kate Bishop, a college student from a very wealthy family who is a highly skilled—and serial trophy-winning—archer, martial artist, and fencer. Thanks to a chance encounter with a certain Avenger who heads into battle with only a bow, some arrows, and a can-do attitude, Kate has hero-worshipped Hawkeye for years, and grown up wanting to be just like him. But when Kate Bishop and Clint Barton's worlds finally collide, it's far from the ideal first meeting.

"When we first meet Kate Bishop, she's away at school, and she's getting herself into trouble, as she does," actress Hailee Steinfeld says of her character, whose archery antics extend to accidentally destroying her college's prized bell tower. "But she is ultimately the kind of person that wants to see people smile. And she wants to help people. She wants to make people feel good. And so, if it means putting herself in somewhat of a compromising situation, she'll do it. But she knows that she's smart enough to get out of it or get around it. Kate, right off the bat, finds herself in a situation where her curiosity gets the best of her. And she ultimately finds herself face-to-face with none other than Hawkeye himself, someone who she has idolized her whole life, her favorite Avenger, and somebody who she is just so in awe over. And she doesn't realize that what got her in the situation to be face-to-face with him in the first place is very bad. And that sets us on our journey of the show."

McKINNON ▶

the battle of NYC

In a flashback scene, we see some of the seismic events of *Marvel's The Avengers* through the wide eyes of a young Kate Bishop. The girl's stunning family home—with views of Avengers Tower—is destroyed by the Chitauri attack, and her father, Derek Bishop, doesn't make it out. Kate only survives thanks to the incredible archery of Hawkeye, irrevocably changing the course of her life—and setting her and Clint on the collision course that leads, more than a decade later, to Marvel Studios' *Hawkeye*.

"Making a connection between Kate and Clint by tying in the events of New York and what happened in *Marvel's The Avengers* was very interesting. It was great to be able to do some keyframes showing her seeing Clint do what he's doing from her point of view," Visual Development Supervisor Rodney Fuentebella says. "Her taking that on and making that be part of her motivation to get over the death of her father and become what she is in the show, I thought was fascinating to deal with."

rodney.f

kate bishop

Introduced in 2005's *Young Avengers #1*, the comic book Kate Bishop shared many adventures with her fellow heroes of the Young Avengers before being drawn into the chaotic world of Clint Barton in Matt Fraction and David Aja's *Hawkeye* series. That book won Kate legions of new fans, not least Visual Development Artist Wesley Burt. "It's one of my favorite comics of the last decade," he says. "So everything I was doing early on was to embed as much of that tone as I could into the art. I just wanted to try to bring that thing to life. I knew there were a lot of elements from the comic book run, and from there I was just having fun. I was imagining her and Clint at Brighton Beach and in South Brooklyn, near the Little Russia area, just trying to picture locations that would fit a real-life version of the graphic novel. I knew it would be Christmastime, so that was always a factor. Kate needed warm clothing that could work for actually being active in combat. Being outdoors, indoors. A little bit of everything."

"I didn't know much about Kate Bishop, other than fans were very excited about her story being brought to life," Hailee Steinfeld says. "And, from there, I just dove right in. It's always so fun to play a character that has all this pre-existing information and a fanbase. So, I was very excited to meet with the team and hear what they were thinking as far as who this character was and what elements from the comics they were going to portray. That's also been a fun process, figuring out who she is and what her voice is and what she looks like. She's a young woman growing up in New York City, and she's got a lot of wit. She's a very brave and charismatic, sometimes annoying, but very skilled, and ultimately a very fun person to be around."

"Kate offers the opportunity for a fresh look at what it means to be a 'human' Super Hero," Executive Producer and Director Rhys Thomas says. "How a person defines themselves based on the choices they make despite their background. As a rich only child, she's someone who's gotten used to the expectations, judgment, and assumptions people make about an individual who appears to have the world at their fingertips, no matter how they behave or how much effort they put in. As a result, she's often underestimated, or her efforts undervalued. But this is what's given her some fire. She's learned to use it. And of course, her internal response has been to set her sights on the highest goal of all: to be a Super Hero."

She's also, Thomas believes, a perfect viewpoint character for the audience. "Kate is someone that you can identify with. She's basically a fan, the closest representative of most of us who have spent over a decade watching these stories and looking in from the outside. She represents that and she's focused on Hawkeye, so she has those eyes into a world that felt really interesting as an access point. And then, as a character, her backstory of coming from wealth and her traumatic relationship with her family is compelling, and her drive and determination in a weird, impulsive need to live that life, just feels very accessible."

Kate's clothing was a result of extensive discussions, according to Costume Designer Michael Crow. "It went in a lot of different directions," Crow says. "We really didn't want her to be too fashion-y. We felt like her wardrobe needed to feel very utilitarian. That said, she comes from a wealthy family. Her clothes don't need to be cheap. Her idea of buying a pair of jeans might be going to Bergdorf's, just 'cause that's where she's used to going. But we did want to keep it very simple for her."

"The first thing I did on the project was imagining what her homemade hero outfit would be," Wesley Burt says. "It's sort of an assemblage of different clothing pieces or equipment. I was looking at a lot of thermal wear and athletic wear, but also wanted it to be stylish and fit her character. One of the main things I came up with is the idea for the half-circle hip-piece on the side, which was a way to represent the circle or hip design from the comic book. It's a different way of creating that circular element on the hip. I had read an outline of the episode where she was going to use all the different arrowheads, which were directly from the comics. I came up with this idea in my head, like, 'Well, instead of having to grab each arrow, what if she has a bunch of extra tips on the side and she could screw them on and kind of customize her whole arrow kit?' And it just kind of made sense to put two and two together to add a neat visual element to her costuming. And I'm really happy that carried through all the way to her final hero suit."

clint barton

Hawkeye is the "human Avenger," according to Rhys Thomas. "I've always found him compelling," Thomas says, "especially the way that Jeremy has played him. There's a sense of this ordinary guy that is just driven by this sense of duty more than anything. He doesn't have the protection of super-powers. And he's gonna get hurt. Yet, he runs into danger with the rest of them." He describes the Matt Fraction and David Aja *Hawkeye* comic book series as helping establish a baseline for the tone of Marvel Studios' *Hawkeye* and being a "huge way in" to how to develop the character on screen. "What I liked about the Fraction run, and I felt translates directly to Jeremy's version of Hawkeye, is this—he's a character that has the weight of the world on his shoulders. He's kind of this put-upon guy. And Jeremy has a wonderful, expressive face. There's so much story in Jeremy's face. You just point a camera at him, you don't need to have him say anything."

Wesley Burt's concept artwork is similarly inspired by Fraction and Aja's *Hawkeye*, right down to the Band-Aids on Clint and Kate's faces. "The comic is so much of them just getting beat up and accruing bandages," Burt says with a laugh. "In addition, Clint's wearing a jacket that's pulled straight from the comic. I love that kind of '60s mod parka. So much of the comic is, like, mod culture, pulling in from different references—music and visuals and '70s cinema and all kinds of stuff. So I just wanted to pull as much of that in too."

Michael Crow sought to "hearken back" to some of the clothing Clint was depicted in in his previous appearances at his ranch home, while remaining conscious that, in Marvel Studios' *Hawkeye*, he would be called into action in fight scenes wearing those garments. That meant building in elements to Clint's ensemble, like a "barn coat" and a denim jacket, that could be taken off as the plot developed, and adding elements like hoodies that "would allow us to get darker as the story went along." Overall, Clint's wardrobe, and its colors, reflect his status as a husband and father, more than as an Avenger. "We wanted him to have a warm, textural tone," Crow adds, "to symbolize that he's trying to recapture that element of his life now that his family has returned."

i could do this all day

Clint Barton is in New York City with his kids to attend *Rogers: The Musical,* an all-singing, all-dancing Broadway tribute to Captain America and the Avengers. And even though Clint can't bear to sit through all of it, a small army of talents were still required to stage the fictional show's stand-out song, "Save the City"—a belter of a number sure to have fans crying out for more. "All of the Avengers got invited, but no one showed up except for Clint," Trinh Tran says. "We had talked about doing a little piece, and then Kevin absolutely loved the idea so much that he wanted us to actually create an entire song, four and a half minutes of it. And then it launched into a whole spectacle, and this musical came to life because we hired an amazing, talented group of people to pull it off. We got Marc Shaiman, composer and lyricist of *Hairspray,* to write the song for us, which is incredible. We hired Josh Bergasse as our choreographer, and he did the whole musical dance. The set is absolutely amazing. The funny thing is, I told Marc on the day when we were filming that he should start writing *Avengers: The Musical.* We absolutely love that we get a chance to make a little musical in the Marvel Cinematic Universe, and we're really hoping that this could be something more."

"I never thought I'd be writing lyrics rhyming Tesseract and Chitauri, but it's come to fruition," Marc Shaiman says. "When we were writing the song, we knew that it had to be a full force Broadway musical number, but we also knew that it had to be something that would make Hawkeye's eyes roll. We tried to balance all that, so I think when you watch the number you laugh at it a little, but you also enjoy it. It's a rousing song." According to Shaiman, no matter what you're writing for, you always start with the same foundation: "What is the story the song is telling? What is the feeling and the emotion? That's where my co-lyricist, Scott Wittman, is so good," he says. "He's the one who said, shouldn't it be the New Yorkers saying, 'save the city—help us, Avengers'? And that's all I need to hear. I just kinda paste it all up on my piano and start playing. And it became this kind of pop/rock gospel song that would not be out of place on Broadway." Inspired by Shaiman and Wittman's work, Josh Bergasse wanted to see "great production value" in the number, from the singing and dancing to the elaborate set. "The overall design of it was really cool," Bergasse says, "making it look like it popped out of a comic book. So a lot of the stuff feels very two-dimensional, with the forced perspective." Building a complete theater set, housed at the Fox Theatre in Atlanta, thanks to its large stage, required extensive concept illustrations and scale models to demonstrate how it could incorporate "pieces of New York City," Production Designer Maya Shimoguchi says. "It's kind of like a giant pop-up book, so that the whole set feels like it's a comic book come to life." Bergasse was amused that, while the production team felt like the set build was very rushed, it all seemed very normal for him with his stage background. "You know what they say on Broadway," he says. "You don't actually ever finish a show—you just have to open."

Concept Artist in the Costume Department Christian Cordella has worked on Broadway shows in the past and brought that experience to bear in the process of designing stage outfits for the performers playing the roles of the Avengers. "It was really fun to interpret those costumes, to bring them to a more down-to-earth version, almost like *Hamilton*," Cordella says. "I was looking at those kind of Broadway shows, where there has to be some stylization in the costumes because they have to be seen from far away. There are all those little lessons that you need to apply when you do one of these costumes for stage." One of Cordella's favorite touches was incorporating the Norse rune Thurisaz, associated with the God of Thunder, into Thor's ensemble, in place of his traditional circles.

"We talked about making a Broadway version of each of their costumes in a more elaborate way," Michael Crow says. "It just started feeling a little hokey and a little cheesy every time we went too far and added too much. So we really dialed back: What are the essential elements that we need to know who those characters are in a flash on stage?"

christmas in new york

"It was important to go to New York," Rhys Thomas says. "I was always interested in really being able to ground this in a way. We don't have a fantastical story that takes us to outer space or takes us to these heightened locations. It's a very real experience and also a very real-time experience. The whole notion is that we're on a day-by-day lead-up to Christmas. So, getting as much of the real texture and the real flavor of New York and feeling these different neighborhoods—experiencing a little bit of the downtown and the uptown contrast, it's hard to fake. It was super important. New York is such a special place at Christmastime." Rodney Fuentebella, a highly experienced concept artist making his debut as Visual Development Supervisor on Marvel Studios' *Hawkeye*, wanted to make sure that the look and feel of the show continued the legacy of Hawkeye in a respectful way. "Aesthetically, the Fraction and Aja comics were something that we were looking at," Fuentebella says. "We wanted to make it feel like the comic, something that has a lot of ground-level action and displays both Clint and Kate in a way that shows what they're good at, while playing upon the whole holiday vibe. We wanted to have a balance of both fun and action, so making it feel like it's Christmastime in New York was very exciting. It's a street-level, action-adventure, fun holiday special."

Kate's wealthy mother, Eleanor Bishop, is far from impressed with having to write a check to cover the cost of her troublesome daughter's destructive stunt at school—so makes Kate attend a charity event at a luxury hotel. But, as glamorous as the event may appear on the surface, Kate's nose for trouble—and her sharp tuxedo that enables her to pass as a waiter—lead her to uncover a seedier operation in the wine cellar below.

Visual Development Artist Andrew Kim was called on to produce storyboards of certain key scenes, including the auction of Ronin's sword—and the moment where Jacques Duquesne purloins it. Conscious of the need to focus on key moments in any sequence, Kim puts understandable emphasis on the instant retraction of the weapon.

Visual Development Artist Henrik Tamm found it fun to "imagine the backgrounds of all these bad guys" assembled at the shady auction, as he came up with all their different faces in his keyframe. Tamm is a classically trained oil painter, and that background comes across in his digital illustration using Photoshop. "I always go back to my classical training," he says. "For me, Photoshop is just a paint box. I use it the same way that I would use brushes and paint. With Photoshop, you have more leeway, you have more tools—you can adjust things more easily than if you painted by hand. You have hundreds of layers. If you want, you can lighten things up, change colors and move things around. That's great, but I still love the hand-painted feel to things." The auction is disrupted as it comes under explosive attack from criminals wearing tracksuits—and, amid the chaos, Kate dons the Ronin suit. Though she is able to fight her way out, she puts herself square in the sights of a deadly gang with a vendetta against the murderous vigilante.

ronin

While, for flashback scenes showing Clint Barton as Ronin, it was possible to use the same costume as shown in Marvel Studios' *Avengers: Endgame*, adaptations were needed for Kate Bishop's version of the costume. "For Kate, we had to build a completely new costume because it would not have fit Hailee in the way we wanted," Michael Crow says. "So we re-created it to fit Hailee, adding elements from the tuxedo she wore to the party."

As well as the practical challenges, putting Kate in the Ronin outfit also involved walking a "tonal tightrope," according to Rhys Thomas. "The suit is so loaded with meaning and with darkness," Thomas says. "It was so compelling and cool in *Endgame* when you discovered that that was the direction that Clint's character had taken, and we wanted to bring it back in a meaningful way. But we had to be careful how we handled it because, if it felt too flippant, the meaning was getting lost. You could almost see it like a poisoned chalice for Kate in some ways—a version of, 'be careful what you wish for.' Everything has been leading Kate to this moment in her mind, but it's the weirdest access point she could have chosen to get to Hawkeye, the guy she looks up to. She actually took his dark side and brought that out. So, it's a great beginning because it sets her on the wrong foot with him."

lucky the pizza dog

Lucky, the so-called "Pizza Dog"—thanks to his food of choice—was "a must for this series," Trinh Tran says. "Pizza Dog is a very, very big part of the Clint and Kate world in the Matt Fraction run," she says, and it was important that this third member of an unlikely trio was integrated into Marvel Studios' *Hawkeye* in a way that made sense, not just included for the sake of it. As played by the "so cute" Jolt, she believes that Lucky "really is a friend to Clint and Kate" in the show. "Seeing Jeremy Renner and Hailee Steinfeld together on the first day with Lucky, that completely blew everybody's mind," Tranh says. "Just having all three of them in frame really solidified how excited we were to bring these characters to life. They've got great chemistry." Truly owning the role, Jolt is "the most gorgeous, humorous doggie who just wants cuddles and love all the time," Co-Director of Episodes 3, 4, and 5 Bertie says. "I've never seen a dog smile so broadly on cue, just with this like human grin. The corners of Jolt's mouth turn up. It's amazing." Wesley Burt was a little unclear on what breed Lucky was meant to be in the comics, so he tried out some different options in his concept artwork. "Initially, I went with a more street dog kind of look, actually based a little bit on one of my dogs—she's kind of scruffy," Burt says. "We don't get to paint animals very often, so Lucky was a good chance to have some fun with that."

w burt

Lucky's intervention in the criminals' attack leads to Kate saving him from traffic and taking him home. Still wearing the Ronin suit, she sneaks into the home of Armand Duquesne III, suspicious of his attendance at the auction—and his vocal opposition to his nephew marrying her mother. Andrew Kim provided storyboards for each of these scenes. "When it comes to storyboarding, the very first thing is to show the clarity," Kim says. "There are multiple ways of showing the exact same images, but it really depends on how you want to portray the sequence, shot-by-shot, to tell the story as clear as possible. That's the number one priority when I'm handed the script." According to Kim, strategy is also important, choosing the right place for close-ups and other techniques. "You want to save up specific shots for certain moments," Kim says. "It comes down to how you want to prioritize the best shots for certain scenes and planning out how you want to build up to that specific, dramatic shot."

ARMAND
DUQUESNE

465 Jones St.
New York, NY, 10014

EXITS O.S
CLOSING
THE DOOR.

What Kate finds is Armand dead on the floor, stabbed in the back. In this moment, she is given a glimpse of exactly how dangerous the vigilante world she has been so desperate to enter can be—and her shock is expertly captured by Rodney Fuentebella in his keyframes. "I like focusing in on a character's look and expression in these moments," Fuentebella says. "I think that's a great thing about the show, how she is seeing what being a hero, or trying to be a hero, means from her point of view— and all the repercussions involved with that. It's the opposite of Clint, who has been there, seen everything. It was great to draw Kate wearing the Ronin costume and seeing how to make it look good, but not too good. But the great thing about doing what we do here at Marvel is trying, not just to do something that looks good, but to also show the tone and the feeling of these characters and convey that as much as possible in our keyframes."

catch and release

Seeing someone running around New York in his old ninja suit on the news ruins Clint Barton's day...and possibly his Christmas. He finds this "Ronin," just in time to save them from the gang of leisurewear-clad assailants, unmasks them—and can't quite believe it's some starstruck 22-year-old. Aware of just how dangerous this gang—and, in particular, the "guy at the top"—can be, Clint is determined to put an end to this whole mess as quickly as possible. He goes with Kate to her apartment to take back the Ronin costume—but when is anything ever that easy? The "Tracksuit Mafia" arrive and torch the apartment. Clint, Kate, and Lucky make it out, but the Ronin suit is left behind, and by the time Clint returns to recover it, it is gone. With things spiraling out of control, he is forced to send his kids home, try to track down the costume, and deal with the Tracksuits while desperately trying to stop his enthusiastic would-be partner from helping. And, thanks to a light-fingered firefighter (and enthusiastic live action role-player) named Grills, that means joining the NYC LARPers guild and doing fake battle in Central Park. As for the Tracksuit Mafia, Clint has a plan straight out of the Natasha Romanoff playbook: catch and release. The first half is easy. The second part? Not so much...

For Executive Producer and Director Rhys Thomas, it was pure entertainment to bring Clint up against "just too much energy," in the form of Kate, and place him in "a situation that's out of his control and almost absurd in the twists and turns it takes." And funny as it is to watch Jeremy Renner express Clint's "moments of exasperation" as he deals with Kate's hero worship, or playacts defeat in combat to Grills, plenty of real danger lies ahead. "Clint's got a lot of past to reckon with," Thomas says. "It's crazy. He's annoyed a lot of people during his time doing good." For Executive Producer Brad Winderbaum, Hawkeye has always been "the human face on the Avengers," and seeing him struggling to balance trying to be a dad with the responsibilities of his very stressful job reflects many people's true-life experiences—albeit in a heightened form. As Winderbaum puts it, Clint lost his family, became the Ronin, and started to "lose his marbles" a little. "In this series, we get to see all the ramifications of that," he says. "Now those chickens are coming home to roost. It's not so easy to go back to being the family man that you were when you were also a vigilante who murdered all these people."

there goes the neighborhood

Kate takes Clint to her apartment, above the Herman's Hearty Slice pizza joint—and trouble soon follows them. Illustrator in the Art Department Scott Lukowski captured an air of foreboding in his exterior illustration. "With each project, the production designer, in this case, Maya Shimoguchi, leads the art department with a unified overall design vision," Lukowski says. "With this in place, my process starts by considering what the audience should feel and how to present that tone visually. My task was to depict a repurposed loft, which Kate inherits, and place it in a nondescript location slightly hidden from the chaos of the city. I began by gathering research on local New York neighborhoods with smaller establishments. The timeworn character within these communities inspired the condition of this environment. Here, only the transportation is modern. Playbills and trash bags dress the streets that house aging architecture and empty lots. A family-owned pizza parlor doubles as the entrance to her loft."

Kate's home is an example of the "grit and groundedness" that informed the visuals of the show, according to Bertie—one half of the Bert and Bertie directing duo that helmed Episodes 3, 4, and 5. "On the streets, we knew we needed to go to New York to get that texture, because you can't really replicate New York texture," Bertie says. "We wanted that grit of Brooklyn. But how do you ground Kate Bishop when the Bishops are so wealthy? And so, while she does have this elevated world of her childhood and where her mother lives, we wanted to show that she wants to steer her life in a different direction. I love all of that wonderful texture and vitality that Maya and her team brought to Kate's apartment—which is also very cool and kind of wish fulfillment-y at the same time."

the tracksuit mafia

The Tracksuit Mafia—a gang of criminals who wear tracksuits and say "bro" a lot—are one of the highlights of the Fraction and Aja *Hawkeye* comic book that Executive Producer Trinh Tran knew she wanted to feature in this series. "We love the Tracksuit Mafia from the comics," Tran says, "but we wanted to make sure that they weren't going to be just funny characters. We wanted to make sure that there's a level of threat and danger that they bring to our heroes. At times they are scary, but at others they're just equally funny in their own quirky way."

They are "almost cartoon characters," says Rhys Thomas, though nonethless imposing for that. "No matter what you're doing in this world, there's always henchmen," he says. "So why not make them fun and give them some color? Those actors were all super great. I think, out of everybody, they got the most into those characters."

In developing their trademark, coordinated look for the screen, Rodney Fuentebella sought to depict them like "a comic book come to life." The artist adds, "I wanted to make them feel tough and gritty and play upon the idea that maybe there could be some kind of ranking with them. Maybe how many stripes they have, or they could be a higher level by either having a different color or having a different type of tracksuit, or something on the chest that shows their ranking. Something simple like that just makes it feel like they're trying to be a more organized group."

"We went around the world talking about different variations," Costume Designer Michael Crow says. "There was a lot of discussion of, 'Is it going to look silly if they're all wearing the same tracksuit?' So we did variations where they were all in different things. But we decided that, in the end, that didn't make them feel like a collective. They're all custom made. We talked about possibly doing a deal with a sportswear company, but, because they're villains, that gets a little tricky. They do bad things. People don't always want to be associated with that. So the easiest way was to build them from scratch." Costume Department Illustrator Jim Oxford did hundreds of different lineup shots featuring different iterations. "They're tracksuits, but imagine they're a military uniform for a gang," Oxford says of his approach. "So if you had certain stripes on it, that made you a certain rank. The most basic one would be a private, all the way up to their general."

before and after

Scott Lukowski was tasked with representing the interior of Kate's apartment, offering insights into her character, both as it should look, and once it has been ravaged by fire. "Kate Bishop is an accomplished archer with training in martial arts and fencing, but she's also a fun-loving and ambitious young adult," Lukowski says. "To help show this, the production designer wanted Kate's loft to be a deconstructed living space with less conventional furnishings and a youthful sense. Chris Cortner, the set deisgner, and I created multiple variations before landing on this commercial space, a former coffee brewery. Kate's personality was on display within her decor, which included such things as a wall-mounted Christmas tree made of empty pizza boxes, colorful lights draped about the room, as well as an archery range, among other essentials. The aftermath of the fire was supposed to be devastating but not total. The process of imagining this grim and moody outcome was inspired by research on abandoned structures and real-life natural disasters."

"We see the Bishop mansion in flashback when Kate is 8 years old, and then we see it in the present day," Production Designer Maya Shimoguchi says. "In the flashback, when her dad is still alive, we were using a much warmer tone throughout the whole house. So it was much more playful. And then, in the present day it's a lot cooler. There's a much more uptight, restricted, curated feel to the house. And it's meant to represent that, in the flashback, she's having this idealized childhood. We're seeing it more from memory, which makes it even more idealized because how you remember things is always nostalgic. That's contrasting with how she perceives her mom to be controlling and strict. And we're trying to represent that in the house."

It was a "real journey" finding the right "scale and level of opulence," according to Rhys Thomas. "It started out as a townhouse, but I felt, it's an uptown thing, it needs to be this penthouse," he says. "I remember, I watched *Bonfire of the Vanities* again, looking at that world, and there's definitely an element of Tom Hanks's apartment that started informing our approach. I think we had three floors, but it was even bigger when we first designed it. It was a really crazy space. But it is all true. As someone who spent all my formative years in New York, you see these different worlds and clashes of culture, with extreme wealth and street-level life intermingling. You'd find a house like this in New York City."

family traditions

The Bishop house—and everything about Eleanor's world—reflects how, following the death of her husband, she strove to keep her daughter safe and maintain the life they had become accustomed to. "First and foremost, Eleanor's motivation is as a mother," Rhys Thomas says. "In our cold open, we see that, while Eleanor's not Kate's favorite parent, she's still compassionate and caring. Eleanor has been overly protective of Kate her entire life—Bishop Security represents more than just a business. It's had a hand in keeping Kate safe and controlling her movement. Kate's life has always had to conform in some way or other to her mother's plan. They may have fought bitterly about it in the past, but eventually Kate found she could get what she wanted

by working around her mother's watchful eye and avoid her scrutiny by appearing to play by the rules. Their adult relationship teeters on the edge of bigger issues, but they've found a middle ground of 'don't ask, don't tell,' for the most part."

As the story plays out, we discover just how far Eleanor has been willing to go to this end. "She has made decisions that were fully justified in her head to protect Kate," Thomas says. "Even though they live this life of wild opulence, that is the kind of cage that she lives in, and she has to now maintain and protect it. You can make those choices, based on love and compassion and something you really believe in, but as time goes by, you can take one wrong

turn, or get pushed just a little bit off course, and then suddenly things have gotten out of hand."

That, according to Thomas, is part of the explanation for the distance that Kate has put between her and her mother. "Eleanor has managed to live this life disconnected from the street level in this mansion on the Upper East Side—but Kate wants to live in a loft above a pizza parlor. Then there's all the various things she's been training at, and the other life she's been leading, which obviously don't quite fit with the delicacy of the Bishop past. That's down to her will for independence, but also possibly something that she can't put her finger on in terms of her relationship with her mother."

bishop security

Maya Shimoguchi established the "basic look" for Bishop Security, according to Art Department Illustrator Michele Moen, who was provided with preliminary shots as guides to paint from. "To be acquainted with the lighting, look, and style of each scene, the art department would send me folders of many reference images," Moen says. "I also looked at global design and architecture magazines and websites for ultramodern and sophisticated details. There was one particular curved wood treatment from an interior in Spain that I was inspired by, but I made it unique to the Bishop Security conference room. Maya would send back specific notes for elements she wanted. For example, she asked for 'vertically fluted obscure glass' in the conference room. Another note was to 'avoid mid-century modern in the furnishings.'" According to Moen, the team "played around with different carpet designs" originated by another artist. As Moen puts it, "The final, approved concept was very much a back-and-forth collaborative effort."

▲ MOEN & ROMIG

Moen worked on several variations for Eleanor Bishop's office, including a "nice touch" that Shimoguchi liked from another artist, "simplifying the background wall using oxblood-colored leather tiles." The key element of the Bishop Security logo, visible in the lobby and elsewhere, was supplied by Art Department Graphic Designer Tina Charad, with several concepts put forward for Moen to incorporate into her concepts in order to see what would "read best in the shot." The artist says, "The first, readable impressions are crucial; if the audience misses an important story-point element, or if an audience only notices that element and nothing else, both instances are not working well for the shot."

clint barton: larper

To get his Ronin suit back, Clint must sign up to the NYC LARPers, don some armor and half-heartedly play-fight his way through to the firefighter who is wearing it, Grills—a name that will be fondly familiar to readers of Fraction and Aja's *Hawkeye*. When it came to developing Clint's larping look, it was important to remember that, for him, this was not a fun way to spend his day, but instead is a means to a very important end. As a result, it had to be a very "makeshift" outfit, made up from whatever the group had lying around for Clint to wear, according to Jim Oxford. "In the storyline, the character is just showing up at the event and sort of randomly putting stuff on," Oxford says. "It wasn't like he was into role-playing. And, in the final show, it really turned out to be much more basic even than my pieces." Michele Moen depicted the more enthusiastic NYC LARPers in action. "These concepts were lots of fun for me," Moen says. "People in costume and in sunlight! I was supplied with several angles of location photos to work with, so I understood the size of the area, and online there are so many battle re-creation photos that it was easy to find inspiration. Some of the medieval costumes are wonderfully textured with furs and armor."

Clint gives himself up to the Tracksuit Mafia with the hope of resolving this whole mess in a straightforward way. He may be held at gunpoint in an abandoned toy store, but he's in control of the situation...right up until Kate Bishop comes crashing through the skylight in a misguided attempt to come to his aid. Though the idea plays out differently on screen, in his keyframe artwork, Visual Development Artist Alex Mandradjiev originally envisaged Kate riding to the rescue...or, at least, trying to. "The idea was simple," Mandradjiev says. "She musters up courage, takes a leap of faith to break in and save Hawkeye from the Tracksuit Mafia. She does it on a bike. The idea is that it looks really, really badass and crazy in the moment, but afterwards she fails pretty badly."

some christmas

Clint Barton should be making gingerbread houses and watching Christmas movies with his kids. Instead, he's duct-taped to a coin-operated unicorn, with his would-be partner right next to him, only making things worse. But he's still an Avenger—and, it turns out, Kate Bishop has some moves too. The pair manage to fight their way out of the frying pan of the toy store, right into the fire of a car chase, where the arrows really start to fly. And directing duo Bert and Bertie loved every minute of it. The pair jumped at the chance to come on board to helm three consecutive episodes in the middle of Marvel Studios' *Hawkeye*. "We love doing those episodes because it's when your characters kind of take off," Bert says. "So, in Episodes 1 and 2, you have to set up the world and the characters and the plot. But we feel like in 3 and 4, you can really get into it emotionally with the characters." On that front, the "buddy cop" tone of the show struck a nostalgic note with the pair of filmmakers, who grew up watching *Lethal Weapon*. "Hawkeye's notoriously been quite serious, a man of few words, and he's still that," Bertie says. "But here it was like taking the Clint from the comics—the Kate and Clint comics—and introducing this irreverent, bickering relationship that was also very grounded. The Hawkeyes are not Super Heroes—they are skilled human beings. So, it was constantly about flawed humans who get injured and get beaten up." They particularly enjoyed the chance to kick things into high gear and blow some stuff up. "We see them in the toy store, and it's the beginning of this epic action sequence against the Tracksuits all through the store," Bertie says. "And it busts out onto the streets of New York, and in broad daylight, they have this epic car chase where cars are spinning. And that's when the trick arrows start to get introduced. So Kate's got this quiver of arrows, but she doesn't know what they each do. And she's testing them all, and some of them are epic and explode. But other ones are just things like putty arrows that deter people, but they're nothing lethal." Clint and Kate make it out alive, just barely, and escape onto the subway—and that's when things really hit home for Hawkeye that his holiday plans are ruined. "We see Clint kind of struggling with what to do next," Bert says. "Like, how does he put the Ronin suit, and what it's uncovered, to bed? He thinks it's going to be a quick solution, and he very quickly realizes it's not going to be. He's not going home to his family, not any time soon."

maya lopez

The Tracksuit Mafia's day-to-day leader is revealed as Maya Lopez, a deaf Native American woman with prodigious fighting skills, also known as Echo in Marvel Comics. Maya debuted in 1999's *Daredevil #9*, written by David Mack and illustrated by Joe Quesada. Making her acting debut, Alaqua Cox is proud to bring the character to the Marvel Cinematic Universe. "Maya is Native, she's from the Cheyenne Nation," Cox says. "And she fits into *Hawkeye* because, when her dad passed away, she kind of took over his position. Her dad is killed by the Ronin, in flashback. He's saying goodbye to her as he dies, and he puts his hand on her face. So you see a blood mark of his hand. That's how Maya actually got involved in looking for the Ronin, because he killed her father. She wanted to know who the Ronin was, but he actually was Hawkeye the whole time. And she had no idea. She thought it was somebody else. And that's how she comes into the story." Cox believes it's an "amazing" step in the right direction that a deaf actor was cast as a deaf character. "This is going to have such an impact on the deaf community at large," she says. "It's definitely going to be a big deal."

The bloody handprint serves as the series' sole reference to the facial makeup that traditionally forms part of Maya's comic book costume, but, beyond that, Concept Artist Wesley Burt did not seek to dramatically reinvent her appearance in his work for this series. "I really liked the comics depiction of her and just wanted to be as true to that as it could, palette wise, design wise," Burt says. "Everything about it, I was trying to pull from the comics. Even the bandage wrapping on the leg is straight from the comics." Burt was, however, requested to incorporate the signature stripes of the Tracksuit Mafia into Maya's ensemble. "Originally it was just a black leather jacket," he says, "but they wanted to show that she's in the gang, and also in a leadership role. So it made sense to apply the lines to just one side of her jacket."

"We were trying to figure out, first, who this Maya character is," Rodney Fuentebella says. "How much should we focus on her Native American self, or her New York self? Does she wear more of a costume, or is she in a little bit more everyday clothing. How much of the comic do we actually pull from? So we tried a bunch of different things. The ones I did delved into her looking a bit more like the Tracksuits, with a higher ranking, and also played on her heritage. Thankfully, Wes was able to nail the look, where it felt like it was something that plays well with the show, is ground level, and still homages her comic book origins."

"I mainly tried to stay pretty true to the source material in the comics," Visual Development Concept Illustrator Imogene Chayes says of her concept work for Maya Lopez. "I just loved her entire vibe. She just seemed like the most badass chick. She also kind of had this rocker, almost punk, attitude, so I wanted to really stay true to that. In the beginning, I pictured her a little older than how she ended up in the show, because they explained to me that she was an actual mob boss. So I'm, like, okay, she's this really powerful woman—that was the approach that I took."

According to Rhys Thomas, when Alaqua Cox was cast, it was important to give her the choice of whether to incorporate her prosthetic leg into the portrayal of the character. "Obviously, she wanted to go for it, and really was proud of it," Thomas says. "And you see why. It became this wonderful thing. Once that became a part of the character and once we started designing her costume and incorporating that, you realize, 'Oh, we've got this other aspect to her.' Number one, obviously, it tells a part of her story, automatically, that it's nothing to her and she has dealt with this. And then, getting to play it as a strength was great too. And I think, going forward with the character, there's a lot you can do with that. Ultimately, it spoke to Alaqua's character. I think it was a nice personal touch. It's not in the comics, but I think it adds this wonderful layer that makes it uniquely hers." Cox says, "I'm very excited to show the world my prosthetic leg. In Episode 6, that's my favorite costume because it really shows who I am as a person and as the character. And I just think that's cool."

Maya communicates using American Sign Language and criticizes Clint Barton for his reliance on a hearing aid, but Rodney Fuentebella explored the possibility that she may have some additional "high-tech element" that would glow and make it easier for other people to see and understand her signing. "We were trying to figure out something that would be fitting in the world, but that adds a little something to her," Fuentebella says. "I came up with these ideas where there could be some kind of biofeedback that can translate what she's saying in some way." In her explorations of how Maya's arm and hand wrappings from the comics could potentially be incorporated in her look, Imogene Chayes sought to take traditional, organic Native American styles of wraps and ties, using raw leathers, and mix them with wiring and metal parts that could form these translators.

In Marvel Comics, Clint Barton was actually the second person to wear the Ronin suit—the first, from 2005's *New Avengers #11* on, was actually a disguised Maya Lopez. As part of the visual development process for Marvel Studios' *Hawkeye*, the opposite idea was explored—that Maya might don Clint's old costume, albeit with some elements of personalization. "The idea was that she would take it and put her own spin on what the Ronin suit would look like," Rodney Fuentebella says. "That's why there are elements like the handprint and some Native American symbology that you can see in the belt, mixed together with the Ronin symbology. I was considering, how much will she alter it and tailor it and really make it her own?"

kazi

Serving as something of a lieutenant to Maya, Kazi is a complex individual, according to actor Fra Fee—with the relationship between the two characters being particularly nuanced. Having spent his entire life being brought up in this world, suddenly Maya becomes the boss when her father is killed. "To all of a sudden have Maya ahead of him, that's a hard pill to swallow," Free says. "And then add into that mix the fact that he genuinely really cares for her. They've been friends for life. I think there's a version of love there, for sure. It's extremely complicated, just because her status is higher than his." As for the Tracksuit Mafia themselves, Free describes them as "slightly larger than life criminals on the streets of New York," saying, "Kazi tries his best to sort of rein them in and keep it as professional as possible." In bringing the character to the screen, major changes were made from the comic book inspiration of Kazimierz Kazimierczak, a lethal killer-for-hire wearing crying clown-face makeup in Fraction and Aja's *Hawkeye*. Initially, according to Rodney Fuentebella, Visual Development Artist Keith Christensen explored a more faithful "assassin feel" for Kazi, who it was considered may have psychological reasons for seeking to conceal his face. Fuentebella himself also experimented with the idea that, in doing so, the character had even mimicked the Winter Soldier, as some sort of "idol." In his designs, Fuentebella also sought to play on the connection between Kazi and Maya, incorporating Native American inspired elements into his ensemble. "But eventually," the artist says, "they made Kazi into what he is in the show—a general to the Tracksuit Mafia."

"This was a challenge," Visual Development Artist Alex Mandradjiev says of his series of keyframes illustrating Clint and Kate being held captive in a toy store. "I remember doing this again and again, how to believably put them on a coin-operated child's ride and how they would be tied up. I just wanted to get a cool cinematic shot where we could get a feeling of the bleakness and emptiness of this place where they were being held." Mandradjiev had to concentrate on the composition and including just the right amount of "artificial color" one would get in an out-of-business toy store. "I could have easily not paid attention," he says, "and just flooded it with a full spectrum color, which would just look like a watermelon painting, which I absolutely hate. All the colors of the rainbow in one shot, ugh."

archers in action

As Clint and Kate flee the toy store, with the Tracksuit Mafia in hot pursuit, a thrilling car chase ensues in which Clint allows Kate to use some—but not all—of his trick arrows. Her life may be in danger, but this is still one of the greatest days of Kate's life—and that mix of terror and exhilaration comes through loud and clear in Rodney Fuentebella's keyframe. "I remember the first time going on a roller coaster," Fuentebella says. "It's kind of scary. You're like, 'I don't know what's going on—where am I?' But at the same time, you're being thrilled. That's the spirit I was going for with Kate. I wanted to capture that sense of kinetic energy—they're being chased and all this dynamic stuff's happening. I wanted her hair to be blowing in this messy way—anything with movement is my jam. In the script, at this stage, the chase was happening at night, rather than in daylight as in the final show, but the bones of it are pretty much what happened. At this stage, she and Hawkeye are just starting to communicate. She pulls out an arrow and then, when she shoots it, it explodes. So that's why I wanted her to have this semi-surprised look—like, 'Oh, what was that?'"

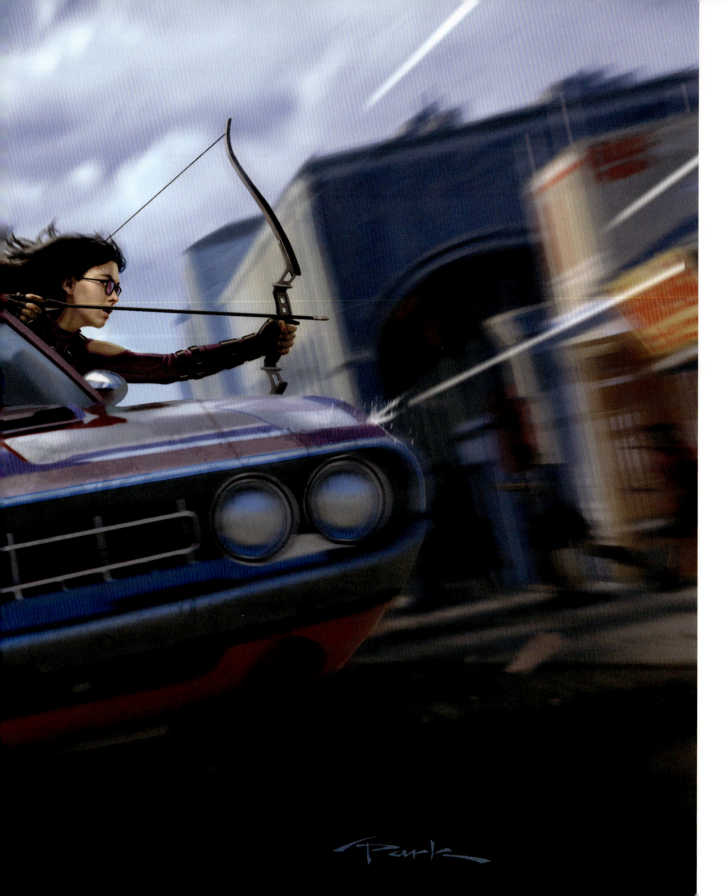

"Suddenly, we were inventing Hawkeye's trick arrows, and it was so awesome," Bert says of the action-packed sequence. "There were more arrows to begin with, and we pared it back—because there is a danger when you can do anything. You want to keep the audience engaged, and we like things to feel real-world and grounded, so we didn't want to get too 'sci-fi.' But there's nothing like having the arrow team asking you what you want."

The car chase was part of the visual development process from the beginning, even if some major changes took place in the final sequence. "Early on, the story was still developing, so, as far as I knew, it was taking place on the West Coast," says Marvel Studios' Director of Visual Development, Andy Park. "In particular, this image was set in Venice, so that's why there's the palm trees, the beach, the boardwalk. I was trying to capture all the fun of the Matt Fraction and David Aja *Hawkeye* run. Clint is on top of the car, annoyed, screaming, as Kate is frantically trying to drive. If you look carefully, she's driving with her feet so that she can lean out the window and shoot arrows." The car—a 1972 Dodge Challenger—is another nod to the Fraction and Aja comics, albeit in the final show, Clint can't bear to steal such an exquisite vehicle. For Park, the fun of keyframes like this is combining the danger and intensity of a car chase with the all-important character moments. "Even though both Hawkeye and Kate are shooting their targets, they're both talking to each other," Park says. "So Hawkeye has his head turned towards her. And he's, like, 'What are you doing? Focus on driving!' And she's like, 'Don't worry, I got this—I'm just as good of an archer as you are.' You can hear their banter. Because that's the key part of this whole show, the development of the relationship between Hawkeye and Kate."

Acid arrow #3

Putty arrow #5

Atmospheric Diffuser (Smoke) arrow #6

a

USB arrow #1

b

USB arrow #1

Gapling Hook-Line Arrow #9

Net arrow #4

Suction cup arrow #2

Razer blade Arrow #7

Masonary Bit Arrow #8

On Marvel Studios' *Hawkeye*, Property Master Russell Bobbitt and Prop Designer John Eaves continued a lengthy and fruitful professional relationship that began with 2009's *Star Trek*. "Russell always gives me the funnest projects," Eaves says. "He lets me run with all these crazy ideas, and a lot of times he'll chime in with some even better ideas. So it's a great collaboration." For the various arrow designs throughout the show, Eaves says, "Russell would send a list over of what they needed, and I would draw some rough sketches. Sometimes he'd say, 'Just make up some pretty interesting things that would make a cool arrowhead, but here are the particular ones that we need the most.'"

SMOKE GRANADE ARROW

net arrow

suction cup arrow

blade tipped arrow

CONCRETE PENETRATING BIT ARROW

ACID ARROW TIP

PUTTY ARROW

USB ARROW

"Russell and I are, I think, two months apart in age," Eaves says. "We were both born in '62. So a lot of these things are based on stuff we played with as kids—like the acid arrow tip. It's based on a rocket. You fill it with water and pump pressure into it and you pull this knob, and that rocket would shoot across the sky. The toy was red and white, and we kind of mimicked that but made it clear so you could see the two acid vials inside. And the putty one is based on the Silly Putty egg, which was kind of fun. The net one was tricky—we had to come up with a unique idea of how this net could be encased in this thing. The blade one is based on three number 11 X-Acto blades, the concrete one we devised out of an actual concrete drill bit that we modified a little bit. For the suction cup, we used a doctor's stethoscope as the basis—it had a really cool shape, as opposed to the same rubber suction cup you see in the rough sketch. We thought, let's do something a little bit more extravagant—something that you could shoot with a little bit more force before it actually sucked on to something."

world's greatest archers

As a weary and sore Clint Barton tends to his many bruises in the apartment of Kate's aunt, far away from his family, Kate brings Christmas to him—complete with ugly sweaters, a festive movie marathon, and a little bit of planning for what comes next. Visual Development Supervisor Rodney Fuentebella got himself into the yuletide spirit and enjoyed putting on his "storytelling hat" with character-filled keyframes depicting the scene. "Kate is being very animated, Clint's just tired," he says. "I put that sad tree on Clint's side, with just that one ornament, but on her side, there's more life and there's the greenery, and a lot of Moira's memorabilia in the background." Not only that, but Clint is icing his wounds. "Because this is in the longer format of a show, we could actually see them being hurt and dealing with the repercussions," Fuentebella says. "In film, it's hard to have that moment. But in the show, we can have it and relish in it." The stark contrast between Clint and Kate carries through to Fuentebella's illustration on page 140. "She's looking happy and excited and is kind of like, 'Oh my gosh, we did all these things!' And he's, like, 'I'm beat up, I'm tired. I just want this event to be over with.'" It sounds a lot like a typical family Christmas—but with a twist, according to Directors Bert and Bertie. "Our episodes weren't the Rockefeller Center," Bertie says of their contribution to the show's holiday setting. "For us, we always talked about sad Christmas. So what we would always want to do is have sad Christmas on fire escapes outside buildings. It's not the glitz and glamor Christmas. This is the back-alley Christmas or the low-grade Christmas." Or, as Bert puts it, "The Dollar Store Christmas." That's what Kate brings to Clint—but, at this point, he'll take what he can get. And as they decorate the tree, watch old films, down daiquiris, and share stories, the reluctant mentor and his overeager protégée finally start to bond. "He really loves it, and he really appreciates it," Bertie says. "And I think, from that moment onwards, even though he's not ready to admit it yet, they're partners. In stories in general, and at Marvel in particular, the car chases and the fight sequences are cool to watch, but what's holding our attention each episode is watching these two unlikely friends—from different generations and different walks of life—bond through their love of arrows."

holiday cheer

As primarily a costume designer, Concept Artist Christian Cordella relished the unusual opportunity offered to him by Costume Designer Michael Crow to "create a little scene" with his artwork featuring Clint, Kate, and Lucky sharing their mini Christmas celebration. "Usually in my designs, characters are standing still with their arms down," Cordella says. "Here I had the opportunity to play around with them. They're sitting down, Clint is supposed to be tired, and they're wearing these crazy sweaters. I could put the dog in there with the reindeer ears, and the little Christmas tree in the back, all the details I was able to put into this apartment. It's thanks to Michael that I was able to have this fun."

operation wristwatch

As if things weren't complicated enough, Hawkeye discovers that another important item was stolen from the Avengers Compound—a vintage Rolex wristwatch. Working remotely from the family ranch, his wife Laura traces its tracking beacon to a New York apartment, and all of a sudden, Clint and Kate have a new mission to complete. But as Kate takes charge of breaking into what turns out to be Maya's apartment, Clint watches from an adjacent rooftop—and comes under attack from a woman in black. A deadly new player has entered the game.

yelena

The mystery assailant is unmasked to reveal the Widow assassin, Yelena—last seen in Marvel Studios' *Black Widow*. "Because Yelena has a lineage, we wanted to figure out what that meant in terms of how much she is becoming her own woman, or how much she is taking a page from her past as the sister of Natasha," Rodney Fuentebella says. "And how does that Black Widow look come into play in her costume?" As a result, Yelena underwent a lengthy design process among the visual development team, during which the work of Visual Development Concept Illustrator Imogene Chayes made a huge impression. "Yelena was the very first character they gave me when I got hired at Vis Dev," Chayes says. "I was like, 'Holy moly, that's awesome. I love her.' I was told that they wanted this outfit to feel like something she could have just bought off the street, as opposed to it being something custom-made. So I took inspiration from fashion brands and referenced a lot of motorcycle jackets, to make it feasible that it's something that she could have found and turned into her own sort of tactical look. It also keeps her a little more incognito, so she's not running around in some flashy Super Hero suit." Returning to the role, actor Florence Pugh could not be happier about her costume design. "One thing that I really wanted with Yelena was that I didn't want her to be in tight suits," Pugh says. "I didn't want her to be a silhouette. I wanted her to be in clothes that she could fight in, that are a different look to what we've seen before." Pugh is pleased that her look has remained consistent in terms of "toughness" and practicality. "It's just the color has changed, which is really cool," she says.

To maintain the mystery of Yelena's initial appearance, Chayes incorporated a version of the "spider eyes" night vision mask that the character has been known to wear in the comics. "That comes pretty much exactly from the comic books," Chayes says. "I was just trying to translate her comic book goggles into something practical and contemporary in the real world, so explored different versions of that. I researched a lot of military night vision goggles and just tried to put a special little spin on it for Yelena."

In her initial designs for Yelena, Imogene Chayes was working from "three prompts" of possible directions for the character's appearance. She says, "The first one was, let's try designing a suit that pays homage to her sister, the Black Widow. The second was just a purely tactical suit. And then the third version is a more incognito look where she can blend into the real world—just her wearing contemporary clothes. These were very nerve-racking, but fun to do as my very first Marvel Vis Dev assignment."

Concept Illustrator Josh Nizzi also explored possibilities for both an updated Widow uniform and a more casual look that would fit in on the streets of New York in winter. For the former, he sought to reference comic book elements like the iconic insignia without being "too bold," exploring the question of how much Yelena might be embracing the mantle of her sister. As for the latter, his favorite is the poncho look, ideal for a rainy day in the Big Apple—something in which she could "blend in, but still be tactical and cool." In Marvel Studios' *Black Widow*, Yelena expressed strong opinions on Natasha's costumes, and very much established her own, more practical style. This played into Nizzi's thinking. "Because of Yelena making fun of the tight-fitting clothes and stuff, you're trying to think of different clothing that would give her more freedom to move around," he says.

At an early stage of the development process, Yelena would have been wearing the Ronin suit for the rooftop fight, according to Rodney Fuentebella, but her true identity would still be shrouded in mystery. "We would have made it feel like, 'Oh my gosh, they're fighting against Maya in the Ronin costume!' But it's not," Fuentebella says. "So the basic premise was we couldn't recognize that it's Yelena." Imogene Chayes was asked to keep her designs true to the original Ronin suit, except "a little more sleek." The artist says, "I wanted to feminize the Ronin suit because, with my own concept art, I like to put in a little attitude and she just has so much attitude. That's fantastic. And I wanted to make sure she wasn't drowning in what was originally a man's suit."

then
and now

Yelena steals the spotlight at the start of Episode 5, as it is revealed in flashback that she was a victim of Thanos' Snap at the end of Marvel Studios' *Avengers: Infinity War*. While on a mission in a beautiful villa attempting to cure a fellow Widow from mind control, Yelena disappears—and returns five years later to find that same Widow, Anna, happily married and raising a family. As she adjusts to half a decade passing by in what, to her, seems like an instant, Yelena must come to terms with all that she has lost—and the shocking news that her sister did not survive. "It's the moment when she essentially Blipped and came back," the episode's Co-Director Bert says. "Really seeing how that emotionally impacts her, finding out about Natasha. That's her drive for getting revenge on Clint."

The devastating impact of these uncanny events are made poignantly real by Florence Pugh's performance, according to Co-Director Bertie. "Florence, you put a camera on her, and it's not just the way she looks," Bertie says. "It's how she brings everything, like this extra layer of depth and realism. We've just been focusing on her face, experiencing what it's like to come back after losing five years of your life. And I felt it literally in my chest as I was watching her. She brings something incredible." That's not all Pugh brings to the role, Bert adds: "She makes fantastic, weird decisions. And she's brave with it. She's always going to bring something to it, like, 'No—Yelena is this.' She takes it to a new level."

As for Pugh herself, she feels her character should always have an "unexpected edge" to her. "You don't really know whether she's going to be in a great mood, or in a pissed off mood," Pugh says. "I want her to be definitely a bit odd and her timing to be unnatural. That's something that makes her quite lovable because she's just this incredibly inter-changing character. I did not see it coming that they were going to put me and Clint against each other, which I thought was a really cool twist." Pugh was thrilled to explore Yelena's "raw and painful" need for revenge, especially against someone that the audience knows loved Natasha as well. All aspects of her dangerously yet adorably unpredictable personality are on display as she continues her pursuit of Clint, by first tracking down Kate Bishop and sharing a hilariously tense encounter that combines casual threats with awkward bonding over macaroni and cheese. Yelena may be the hero in her own head, but for Kate and Clint, she's just one more villain to add to the list. "That's a fascinating thing to be," Pugh says. "A good person, but to everybody else, she's bad. That's an interesting line to walk."

truth

Having learned that Maya Lopez knows about his family, Clint is determined to protect them—and, using a special messenger arrow, arranges a meeting with her at the Fat Man Auto Sales lot. He dons the Ronin suit one last time and, after an initial skirmish in which the pair are evenly matched, he manages to gain the upper hand. But rather than killing her, he reveals his face and explains everything to Maya. The night he attacked the Tracksuit Mafia and killed her father, Clint was given a tip-off by an informant that works for Maya's real boss. The revelation leads her to become suspicious of Kazi. This all plays out in an atmospheric location that directors Bert and Bertie were able to have made to their specifications. "We could design it from scratch, it was incredible," Bert says. "It was just an empty lot, and suddenly there was a building. And, cinematically, it could be exactly what we wanted it to be. This was one of the great examples of Marvel really supporting us, with a very talented team, and creating something that was in our heads. That's how you get the incredible scene with the perfect set—because we created it. So it sets a very distinct tone." Bertie adds that it was a delight to come up with a set that "felt gritty and raw and also wonderfully retro." She says, "There's something very timeless and a bit dated about the Tracksuit Mafia. So we were like, well, if it's going to be an auto repair shop, then we really just want 1970s and '80s cars in there. There was a real vintage quality to it. It felt a bit Scorsese, in a way—like a gangster movie from a bygone era." In his illustration of this important location, Illustrator in the Art Department Scott Lukowski wanted the used car lot to feel "void of life after hours." To achieve this, he used an "almost monotone palette to invoke a sense of uneasiness and isolation." The artist says, "The vehicle inventory is beginning to thin out and sits in a setting that follows a day depressed by cold rain. A dim ambiance from the lights above and a clouded night sky was added to complete the tone."

For the messenger arrow, Prop Designer John Eaves and Property Master Russell Bobbitt had to design a way that the arrow could pierce the windshield of the Tracksuit Mafia's vehicle, but go no farther, in order to reveal Clint's message for Maya. "That's what those kind of picture hangers are there for," Eaves says. "So the arrow can enter whatever it has to pierce and those would stop it, so you can have your little message vial there in the center. So that was the interesting thing—what would we come up with that would stop an arrow from going through that? Thank goodness for the science fiction world where the physics are such that these things work perfectly! The tips were based on high-velocity rifle shells, with a little mixture of a plumb bob in there, which has a wicked point."

scroll arrow

what heroes do

At the end of Episode 5, Yelena messages Kate Bishop to tell her that it was her mother that hired Yelena to kill Clint Barton. Not only that, but she sends a photo of Eleanor Bishop meeting with the very same man that Clint has been worried about this whole time. The clues were there throughout the series about the "big guy," Maya's "uncle," and the ultimate proprietor of Fat Man Auto Sales—but the revelation does not disappoint. With the larger-than-life arrival of Wilson Fisk, the Kingpin, the stakes are raised—and the stage is set for a grand finale featuring all the players.

And where better to host it than the Bishop Christmas party, held at Rockefeller Center, the very heart of a New York Christmas? Hawkeye tried to keep Kate out of all this, but now it's time to finish this, and he needs her help. Everyone is converged on the event of the season; Clint and Kate dressed up to the nines—in more ways than one; the NYC LARPers running recon; Eleanor, of course, and a very understanding Jacques; Yelena, out for blood; Maya, Kazi, and an entire army of Tracksuit Mafia goons converging on the scene; and, casting his giant shadow over it all, the Kingpin. It's time to get the party started—and what starts with tuxedoes and fancy dresses reaches a climax with Clint and Kate in their specially made complementary costumes, fighting for survival side by side on the ice rink, with a whole arsenal of trick arrows.

"Throughout the whole series, they're sort of on opposite sides and don't really work together well," Visual Development Supervisor Rodney Fuentebella says of this culmination of the oft-fractious relationship between the pair. "But this is the moment where they come together—and they're fighting, almost like a dance, in a very cooperative way against all the craziness and the Tracksuit Mafia, with all the arrows flying everywhere. It was awesome having both of them together in their full hero costumes. Kate's dream was to have matching costumes with her idol, and I thought that was cool to see." For Executive Producer Trinh Tran, the two-sided "mentor/ mentee" aspect was always what she was striving to showcase in Marvel Studios' *Hawkeye*, and she believes that, over six episodes, the two characters have "learned a lot from each other." That, for Tranh, culminates as they suit up together at last. "I think that really signifies the partnership that has evolved between the two characters, and that's what you see in the final fight."

wilson fisk

The reveal of the ultimate architect was the subject of a pivotal development meeting that Trinh Tran and the rest of the Hawkeye team were having over Zoom with Marvel Studios President Kevin Feige. "In the script, we had a character named the Boss, who's the mastermind behind everything—who's pulling the strings, who's working with Eleanor Bishop, that we find out later in the series has been the big bad guy," Tran says. "We were wanting to make sure that he would come off completely terrifying to our heroes, especially to Clint Barton because they have a connection during his days as Ronin. Kevin threw out the idea, what if this could be Kingpin? And I think all of our jaws just dropped. I was like, 'Wait, you're joking, right? Are you serious? You really think that there's a chance that we can actually get Vincent D'Onofrio, who played Kingpin in *Marvel's Daredevil*, in this series as our big boss?'"

It turns out, Feige was serious, and, when he made the call, D'Onofrio was very interested. "I jumped on a call with Vincent with the biggest grin on my face, and I swear I could've spoken to that man for hours on end," Tranh says. "Vincent loves playing Kingpin, and it shows, because he is so detail-oriented. He brings to light every movement of how this character comes to life. We had an hour conversation about what we saw in this character and what direction we wanted to bring him into. As Kingpin, in *Daredevil*, he is a big, menacing guy. But in *Hawkeye*, what we wanted to really show is this completely different Kingpin. In the comics, he's just this massive beast—this huge menacing creature. Visual Effects Supervisor Greg Steele was toying around with this concept art—the shot of him sitting at the table devouring his food at the restaurant— and he took that concept art, and he blew up the Boss. He blew up Vincent in a really big way. I sent it over to Kevin, just to sort of gauge his excitement. And he said, 'Wow, I can't believe we're doing this.' And to put him in that Hawaiian shirt and that white blazer outfit was kind of like a dream come true because it's that iconic Kingpin. I remember being on set with Vincent, and he was like, 'That's my screensaver.' I'm like, 'Oh my god, I can't believe I'm seeing you in real life in the Hawaiian shirt.' I couldn't be more happy to have him be a part of this journey with us."

Referring to his in-depth discussions with Tranh, D'Onofrio says, "I was able to explain how I feel about the character and what motivates the character. Fisk is really driven by emotion. He's like a child and a monster both at the same time. And she was able to pass that on to the writers and to other people involved. And I sent them the art that I thought portrayed the character in this world." The actor cites David Mack and Bill Sienkiewicz among his favorite artists that have depicted Wilson Fisk in fully imposing fashion. As D'Onofrio sees it, the Kingpin lost a lot of his connections and money following the Battle of New York. "He's kind of in a desperate situation, but he's trying to gather up his power again—it's a struggle to maintain his dignity. So there's this combination of him being down and out, and also the idea of him reminding his peers and everybody else around him that he is the boss. He is the mastermind. That's the gist of the character. It's sort of a new beginning for me as the actor playing him."

"I knew the reveal of Kingpin would be a pivotal moment in the narrative," Illustrator Scott Lukowski says. "He's such an iconic villain. Each iteration of him has a common thread, a menacing grace that commands respect and delivers fear. Personally, I favor the larger-than-life version by Esad Ribić, but thought a scaled-down adaptation would allow him a better fit at his private table. Here he is eating at his restaurant after hours with no one around. Kingpin is stopped mid-pose seconds before taking another bite. At this moment, we feel a frightening sense of calm and confidence. I couldn't help but include a tone similar to Marlon Brando's character in *Apocalypse Now*."

The Esad Ribić cover for 2016's *Civil War II: Kingpin* and David Ross's artwork depicting the complex relationship between Maya Lopez and Wilson Fisk from 1999's *Daredevil* #9 were among the Marvel Comics sources that influenced the approach to the Kingpin. "There were a couple of comic book covers and illustrations that we really zeroed in on as looks that we wanted to build," Costume Designer Michael Crow says, "and we actually made more clothes than we ended up using, knowing that we weren't sure which one was going to be the final look. We settled on the white suit and the Hawaiian shirt, which worked brilliantly." Most importantly of all, Fisk's clothes had to be big. "We had to build his body out to feel as massive as Kingpin does in the comic books," Crow says. "Vincent's always been amazing as this character. But to be able to then add the mass and really create the character that's in the comic books is just adding a level onto that performance that we were all excited about."

ROSS, MORALES & ISANOVE ▲

way too dangerous

"I always enjoy designing within iconic buildings like Rockefeller Center," Illustrator Scott Lukowski says. "Especially at Christmastime when everything is dressed in bliss. Here I took an existing space and began to tie in some of the Rockefeller elements, such as the scalloped columns. Art Deco bollards, Christmas adornments, and a golden overtone were added to complete the warm and inviting space—perfect for a chase scene to upend!"

SNAP POINT

TURNS INTO SOME WILD Nunchakus

3 pouch quiver

Prop Designer John Eaves started out basing his bow designs on a traditional longbow and he and Property Master Russell Bobbitt had to figure out a way to make it "come apart so you could swing it around and fold it up." Eaves says, "We designed the bow around how it could be taken apart, and how each piece would go together. With the quivers, one of the things I always felt as an audience member was that his quiver never had enough arrows in it. So we did this three-layered box, based on an old art box where you'd put all your pencils and paintbrushes in its three chambers. It was solid in the beginning, and Russell needed me to make it into a canvas version. The arrows only really line up physically at the end with the feathers—but if they really had all those big, unique tips, you wouldn't be able to line them up as close as they are. Thanks again for the sci-fi world where everything works wonderfully!"

arrow intact

splits when fired

chocker wire in place

magnetic arrow head

magnetic arrow

Throughout Marvel Studios' *Hawkeye*, Kate is fascinated by Clint's trick arrows, and desperate for a chance to use them—small wonder when Russell Bobbitt and John Eaves' designs are so darn enticing. From one based on an "old fishing jig" to the one with a squeaky toy gopher on its tip, there's an arrow for every occasion. One of the trickiest to work out was the one with the "choker wire in the center of it," Eaves says. "That was one of the harder ones, at least to make it believable how that arrow would split in two with a wire in the middle. So it's actually two halves of an arrow, weighted just correctly to do what they have to do. It has a little slit the wire would fold into, so the arrow could come back together perfectly. And with that Marvel magic, it just works."

FLARE ARROW TIP

PAPER WEIGHTS BOLO

SONIC ARROW HEAD

kate bishop

The comic book Kate Bishop has spent a lot of time on the West Coast, in a climate more suitable for a costume that features cutouts on her shoulders and hips. This posed a design challenge for Rodney Fuentebella and his team. "For her main hero costume that she wears in the finale, the thing we were trying to figure out is that, unlike in the comics where she's in Los Angeles, she's going to be in New York in the middle of winter," Fuentebella says. "We can't have her wear cutouts, because that would just be unrealistic. So how do we still get that iconic comic book feel but make her tactically well equipped for what she's going to be dealing with? So, we thought she could wear some kind of pauldron on her shoulder that's kind of formfitting. And then Concept Artist Wesley Burt came up with the awesome idea of having, instead of that circular thing in her waist area, a half-circle of arrowheads that kind of connotes that same feel. So I adopted that into my design. And then the chevrons, that were kind of the icon for Hawkeye in the comics, were something that could be the thing that links her to Clint when he has his outfit—that could be the symbolic, heroic motif that will make him stand out and not be lost in the crowd. So, for her outfit, I wanted to put all these chevrons in—definitely in the chest, but also in various places like her arm and her leg, even her back, just everywhere. She's so into wanting to make an iconic look that people remember."

As Marvel Studios' Director of Visual Development Andy Park was illustrating his very early concepts for Kate Bishop, the series was going to be set on the West Coast, where many of the character's comic book adventures have been based. Knowing that Kate grew up idolizing Hawkeye was Park's guiding influence. "I had the good fortune of being able to design Hawkeye for most of his appearances, including his first one, throughout the Marvel Cinematic Universe," he says. "So, being intimately aware of his design sensibilities, I tried to infuse some of that in hers, while combining with her comic look and definitely leaning on the purple. She's got interesting cutouts in her comic costume, from one exposed arm, to the deltoid on her other arm, to even the sides of her hips. You do all these things because they're more comic accurate, but you're also aware that it could be impractical. She's got

the Band-Aid there, so maybe those cutouts are not a good idea. And, beyond the realism of it, I'm also thinking about the practicality of the actual costume build. Those kind of exposed holes at the deltoid and the hip area could cause problems. But, you know, this is an early phase, so I'm going to do the most iconic look. I also wanted to give a nod to the Jimmy Cheung version from *Young Avengers*, especially with her scarf and the sunglasses." As ever, with his character designs, Park isn't just depicting a costume, but telling a story. "We're trying to convey, not just what they are wearing, but who this character is," he says. "You have to encompass all that in one image. So that's why she's leaning up against a wall. She has her bow ready, but her legs are crossed, she's relaxed. The environment factors in as well. And then, you top it off with a smirk."

Despite everything, Kate has reluctantly begun to like Yelena—and, in return, Yelena finds Kate Bishop (she always includes "Bishop") hilarious. But, with the Widow determined to find and kill Clint Barton in this frantic finale, Kate and Yelena face off for some physical sparring on an office floor above the party below—and it's "different from your typical duel," Scott Lukowski says. "They're both highly trained and deadly adversaries, yet they intentionally clash with caution. Their objective wasn't to injure the other, making this confrontation more amusing rather than grave. Hopefully, these frames were successful in getting that across."

'tis the season

To truly capture a New York Christmas, for Trinh Tran, it was essential to film in the Big Apple as much as possible—however, setting your big finish in the Rockefeller Center and having the huge tree be a major casualty of the battle is, she concedes, "pretty ambitious." As a result, the iconic location had to be painstakingly re-created over 800 miles away. It was a "completely uncanny, absurd experience" to be in an industrial area of Atlanta surrounded by a perfect replica of Rockefeller Center at Christmas, Executive Producer and Director Rhys Thomas says. "Our art department did an amazing job. It sounds super cliché, but you forgot that this was not the real place. When you were down in that ice rink, it wasn't a stretch to feel Rockefeller Center. It was bonkers." Scott Lukowski was thrilled to provide illustrations for the "final stand-off," adding, "This was a great scene to illustrate—unexpected yet effective. Bringing down the tree allowed the partygoers a safe escape while the Tracksuit Mafia was trapped on the other side with our heroes. This earlier take evolved into a version with scattering tree decor, spotlights rotating on the ice, and a panicked rush of ball gowns, black ties, and cocktails."

clint barton

Throughout Marvel Studios' *Hawkeye*, Kate has been telling Clint that he needs to improve his branding. At last, for the big finale in Episode 6, he finds his look, in a costume designed by Kate and created by members of the NYC LARPers—on screen, at any rate. Behind-the-scenes, however, its initial visual evolution rested with Rodney Fuentebella, who was working on the final outfits for both archers in tandem. Once again, the Matt Fraction and David Aja *Hawkeye* series was a major influence. "In the comics, he's wearing a T-shirt," Fuentebella says. "So some of my concepts are just him wearing a shirt that has a chevron logo on it. The director wanted him to look a bit more tactical, but we didn't want him to look as tactical as he was in his previous incarnations. We wanted to make it feel different, like a shirt, but still with tactical lines and that feel to it, without it actually being what he was wearing back in *Marvel's The Avengers*. Trying to figure that out, I was looking at lines that I pulled from athleisure wear and workout clothing, as well as tight-fitting military outfits, and seeing how we could pull that off. I gave him that circle that Kate has as well, the one on the shoulder. In the end, what we chose was something that felt like it was fitting to Clint and his more serious personality. It feels like it's still him, but you see in the show that Kate was so happy that he's wearing the outfit she designed for him and that they're going to be matching. I thought that was cool."

Tasked with bringing Fuentebella's artwork to life, Michael Crow and his team kept the focus on utility, ensuring that both Clint and Kate's costumes felt more like sportswear: "Something that you could move in," Crow says. For him, shared design elements including the chevron and the purple-and-black color scheme make this unlikely duo feel like a collective. "This is the moment in the story where they become a team," Crow says. "So this is the moment where you really want them to feel like they're connected and they're of a piece. And I think we accomplished that with the costumes for each of them."

Eleanor Bishop may be a criminal, but she's still Kate's mom. As a result, Kate won't leave her to the mercy of Wilson Fisk. That means that, while Clint is finally resolving matters with Yelena, Kate must single-handedly face the man mountain that is the Kingpin. "It was really interesting working with such a significant character," Visual Development Artist Andrew Kim says of storyboarding Fisk's climactic battle with Kate. The artist was provided footage from the *Marvel's Daredevil* series showing how Wilson Fisk moved and fought in that show as reference. "The visual appearance of him and how much he occupies the scene—he alone can easily take up the whole shot—was something to consider when I was planning things out," Kim says. "It's always fun to play around when the proportions are quite different between two characters. Here, Kingpin is like two or three times the size of a regular man, so it's like David and Goliath. And, obviously, Kate is far less strong than the Kingpin. So it was interesting coming up with how they could be sharing punches and kicks and different ideas to use in this fighting sequence."

home for christmas

He may be battered and bruised, but Clint Barton makes good on his promise. On Christmas Day, he arrives back at the ranch in time to open the presents...and he has a couple of strays along for the ride. Kate Bishop may have left her mom behind bars, but as she and Lucky join Clint and the Bartons for the holidays, she has a newfound family. "Clint had to make it home for Christmas," Rhys Thomas says of the show's inevitable ending. "I love Christmas movies, and we got to live in Christmas for months. It was fun—summer in Atlanta and throwing snow down." But even with all that festive cheer, it's still a "bittersweet" send-off for our heroes. "Clint comes out the other side having done the right thing and maybe found his way back to his true sense of self," Thomas says. "And Kate has learned about her mother's darkness, but that sets her up to continue on in a more independent way. She knows she has this new surrogate family if she needs it, but at the same time, there is a sense of reset. I like to picture her driving off out west and continuing that adventure."

Clint returns the watch to its rightful owner, his wife Laura, and—together with Kate—barbecues the Ronin suit once and for all. The moment serves as a cementing of their partnership, with Hawkeye telling the world's other greatest archer just how proud he is of her. They have the skills. They have the bond. They have the matching suits. The only thing left is for Kate to choose just the right codename...

I am so proud and honored to be the Visual Development Supervisor on this show. Marvel Studios' *Hawkeye* on Disney+ is the first Marvel Cinematic Universe project on which I got to be a supervisor leading the visuals. Hawkeye finally gets his own show, and I got to create the looks of both Clint and Kate. Crazy! I remember the first time I got to see Hawkeye was on the computer screen of Andy Park. He designed the look of Hawkeye from *Marvel's The Avengers* to Marvel Studios' *Captain America: Civil War*. Wesley Burt did the look of Clint as Ronin (as well as Kate's first homemade costume on this show). They did such amazing work on Hawkeye and helped create an indelible Super Hero in the MCU. Hawkeye is one of the most relatable characters in the MCU, which I love. He wants to do good and be with his family as best he can. He does not have Super Soldier Serum coursing through his veins, nor can he shoot lightning or fly. Kate, similarly, is a skilled individual, makes mistakes, is headstrong, and is caring, and learns to pick herself up. Both Clint and Kate have lives that are real and relatable. I feel proud to be a part of a project that brings to light these amazing characters and that was both memorable and exciting.

The Matt Fraction and David Aja comic series heavily inspired the feel of the show and how we approached the visuals. The ground-level depiction of Hawkeye in the comics has a slice-of-life angle that we have rarely seen in the MCU. When I worked on *Captain America: Civil War*, I felt that was the closest I had come to creating a real-world feel in the MCU. In *Civil War*, it was exciting to really see how a Super Hero deals with ground-level threats and difficulties. *Hawkeye* has a similar feel and is based in New York City with a winter holiday flair. I love the idea of this! It felt like a mash-up of a crazy Christmas feel-good movie with a Super Hero team-up. Too cool!

Thanks to Head of Visual Development Ryan Meinerding for mentoring me (in this show and beyond). Who can ask for a better mentor than Ryan? He helped my design of Kate and Clint to be as iconic as possible, to get to the heart of the concepts and make them true Super Heroes! Thank you to Director of Visual Development Andy Park for creating the initial concepts of Kate and Hawkeye, and to Jackson Sze for creating stunning concepts and for navigating with me this whole supervising thang. Thank you to Wesley Burt for the first hero looks of Kate and Maya, Imogene Chayes for the final looks of Maya and Yelena, Rob McKinnon for your cool key frames, Josh Nizzi for your inspiring concepts, Henrik Tamm for the key frames that brought the world of *Hawkeye* to life, Alex Mandradjiev for the jaw-dropping illustrations, and Andrew Kim for drawing such cool shots. You all are too good!

On this project, I got to work with such amazing artists, directors, producers, costume designers, and all the Marvel Studios executives and crew. I remember meeting Executive Producer Trinh Tran and Production Manager Bojan Vucicevic (who was part of our Vis Dev group and an all-around great guy) to pitch us the direction of the Hawkeye show. The work they did on the show behind the scenes is crazy, but that kind of work and dedication is what help make *Hawkeye* so special. I was excited to work on the show from the start. Even with the pandemic making production a bit more interesting... What a time! Thank you, Rhys Thomas and Bert and Bertie, for being awesome directors and collaborators on this project. Thank you to Kevin, Lou, Brad, Victoria, and the rest of the Marvel Studios team who made this show and the journey such an exciting and rewarding adventure. Woo-hoo!

Rodney Fuentebella

DIRECTORS BERT & BERTIE are BAFTA award-winning writers/directors who have worked extensively in both film and television. They most recently directed the pilot of *The Walking Dead* spinoff for AMC as well as *Lessons in Chemistry* for Apple starring Brie Larson. The pair also directed science-fiction thriller *Silo* for Apple TV+, *Our Flag Means Death* for HBO Max, and a three-episode block on Marvel Studios' *Hawkeye*, starring Jeremy Renner, Hailee Steinfeld, and Vera Farmiga. Additionally, they have directed multiple episodes of *The Great* on Hulu starring Elle Fanning. Bert & Bertie burst onto the scene with their feature directorial debut, *Troop Zero*, starring Academy Award winners Viola Davis and Allison Janney for Amazon. The film premiered at Sundance in 2019.

DIRECTOR RHYS THOMAS is a director, writer, and producer born and raised in South Wales. He is best known for co-creating cult favorite, *Documentary Now!* and for his work for *Saturday Night Live*. During his tenure as film producer and director at SNL, he crafted over 100 shorts and won an Emmy Award as a producer of its 40th Anniversary Special. He has also been Emmy nominated for his work as a director on *Documentary Now!*, as well as for his collaboration with John Mulaney on the off-beat children's special, *John Mulaney & the Sacklunch Bunch*. He also directed and produced the critically acclaimed Amazon show, *Comrade Detective*, for A24, starring Channing Tatum and Joseph Gordon Levitt.

PRODUCER AND MARVEL STUDIOS PRESIDENT KEVIN FEIGE has played an instrumental role in a string of blockbuster feature films adapted from the pages of Marvel comic books over the past decade. In his current role, Feige oversees all creative aspects of the company's feature-film and home-entertainment activities. In 2021, Feige produced the following films and shows for Marvel Studios: *Ant-Man and The Wasp: Quantumania, Black Panther: Wakanda Forever, Werewolf by Night, Thor: Love and Thunder, Ms. Marvel, She-Hulk, Moon Knight, Doctor Strange in the Multiverse of Madness, Spider-Man: No Way Home, Hawkeye, Eternals, What If...?, Shang-Chi and The Legend of The Ten Rings, Loki, Black Widow, The Falcon and The Winter Soldier,* and *WandaVision*. His previous producing credits for Marvel Studios include *Spider-Man: Far From Home, Avengers: Endgame, Captain Marvel, Ant-Man and The Wasp, Avengers: Infinity War, Black Panther, Thor: Ragnarok, Spider-Man: Homecoming, Guardians of the Galaxy Vol. 2, Doctor Strange, Captain America: Civil War, Ant-Man, Avengers: Age of Ultron, Guardians of the Galaxy, Captain America: The Winter Soldier, Thor: The Dark World, Iron Man 3, Marvel's The Avengers, Captain America: The First Avenger, Thor, Iron Man 2,* and *Iron Man*.

EXECUTIVE PRODUCER AND MARVEL STUDIOS CO-PRESIDENT LOUIS D'ESPOSITO served as executive producer on the hits *Iron Man, Iron Man 2, Thor, Captain America: The First Avenger, Marvel's The Avengers, Iron Man 3, Thor: The Dark World, Captain America: The Winter Soldier, Guardians of the Galaxy, Captain America: Civil War, Avengers: Age of Ultron, Ant-Man, Doctor Strange, Guardians of the Galaxy Vol. 2, Spider-Man: Homecoming, Thor: Ragnarok, Black Panther, Avengers: Infinity War, Ant-Man and The Wasp, Captain Marvel, Avengers: Endgame, Spider-Man: Far from Home, WandaVision, The Falcon and The Winter Soldier, Black Widow, Loki, Shang-Chi and The Legend of The Ten Rings, What If...?, Eternals, Hawkeye, Spider-Man: No Way Home, Doctor Strange in the Multiverse of Madness, Moon Knight, She-Hulk, Ms. Marvel, Thor: Love and Thunder, Werewolf by Night, Black Panther: Wakanda Forever,* and *Ant-Man and The Wasp: Quantumania* . As co-president of the studio and executive producer on all Marvel Studios films, D'Esposito balances running the studio with overseeing each film from its development stage to distribution. In addition to executive-producing Marvel Studios' films, D'Esposito directed the Marvel One-Shot *Item 47*, which made its debut to fans at the 2012 San Diego Comic-Con International and was featured again at the L.A. Shorts Fest in September 2012. The project was released as an added feature on the *Marvel's The Avengers* Blu-ray disc. D'Esposito also directed the second Marvel One-Shot *Agent Carter*, starring Hayley Atwell, which premiered at the 2013 San Diego Comic-Con to critical praise from press and fans, and is an added feature on the *Iron Man 3* Blu-ray disc. The One-Shot's popularity led to development of the TV series *Marvel's Agent Carter*. D'Esposito began his tenure at Marvel Studios in 2006. Prior to Marvel, D'Esposito's executive-producing credits include the 2006 hit film *The Pursuit of Happyness*, starring Will Smith; *Zathura: A Space Adventure*; and the 2003 hit *S.W.A.T.*, starring Samuel L. Jackson and Colin Farrell.

EXECUTIVE PRODUCER TRINH TRAN is currently a Production & Development Executive at Marvel Studios and served as executive producer on *Hawkeye, Avengers: Infinity War,* and *Avengers: Endgame*. She also served as an associate producer on *Captain America: Civil War* and as a creative executive on *Captain America: The Winter Soldier*.

HEAD OF STREAMING, TELEVISION, AND ANIMATION BRAD WINDERBAUM joined the Marvel universe during the production of Marvel Studios' first theatrical release, *Iron Man*, and went on to become an executive producer on such projects as *Thor: Ragnarok* and *Black Widow* and was a producer on *Thor: Love and Thunder*. Winderbaum serves as an executive producer on Marvel Studios' Disney+ series, including *Hawkeye, What if...? Ms. Marvel, She-Hulk, Secret Invasion,* and many other upcoming shows.

Over the course of his career at Marvel Studios, Winderbaum has co-produced the first *Ant-Man* film and created the *Marvel One-Shot* program of shorts, acting as executive producer on *Team Thor* parts 1 & 2, *All Hail the King, Agent Carter, Item 47, The Consultant,* and *A Funny Thing Happened on the Way to Thor's Hammer*. During Phase 1 of the Marvel Cinematic Universe, he developed the MCU's first interlocking timeline and produced behind-the-scenes documentaries and interactive campaigns for *Iron Man 2, Thor, Captain America: The First Avenger* and *Marvel's The Avengers*. He is also an executive producer on the *Assembled* series of behind- the-scenes Disney+ specials.

Before joining Marvel Studios, Winderbaum was a pioneer of early online storytelling, receiving both an Emmy® Award for Outstanding Broadband Drama and a Webby People's Choice Award for an interactive series he wrote and directed entitled *Satacracy 88*. He received an MFA in film production from USC and a BFA in studio art from NYU, where he staged underground theater productions and created countless surreal illustrations. When he was a freshman in high school, he designed the school district logo in Clarkstown, New York, where he grew up.

MARVEL STUDIOS PRESIDENT, PHYSICAL & POST PRODUCTION, VFX AND ANIMATION PRODUCTION VICTORIA ALONSO most recently served as executive producer on *Ant-Man and The Wasp: Quantumania, Black Panther: Wakanda Forever, Werewolf by Night, Thor: Love and Thunder, Ms. Marvel, She-Hulk, Moon Knight, Doctor Strange in the Multiverse of Madness, Spider-Man: No Way Home, Hawkeye, Eternals, What If...?, Shang-Chi and The Legend of The Ten Rings, Loki, Black Widow, The Falcon and The Winter Soldier, Captain Marvel, Avengers: Endgame, Spider-Man: Far From Home,* and *WandaVision*. In her executive role, she oversees postproduction and visual effects for the studio slate. She executive-produced Joe and Anthony Russo's *Avengers: Infinity War*, Peyton Reed's *Ant-Man and The Wasp*, Ryan Coogler's *Black Panther*, Taika Waititl's *Thor: Ragnarok*, Jon Watts' *Spider-Man: Homecoming*, James Gunn's *Guardians of the Galaxy Vol. 2*, Scott Derrickson's *Doctor Strange*, Joe and Anthony Russo's *Captain America: Civil War*, Peyton Reed's *Ant-Man*, Joss Whedon's *Avengers: Age of Ultron*, James Gunn's *Guardians of the Galaxy*, Joe and Anthony Russo's *Captain America: The Winter Soldier*, Alan Taylor's *Thor: The Dark World*, Shane Black's *Iron Man 3*, and Joss Whedon's *Marvel's The Avengers*. She co-produced Jon Favreau's *Iron Man* and *Iron Man 2*, Kenneth Branagh's *Thor*, and Joe Johnston's *Captain America: The First Avenger*. Alonso's career began at the nascency of the visual-effects industry, when she served as a commercial VFX producer. From there, she VFX-produced numerous feature films, working with such directors as Ridley Scott (*Kingdom of Heaven*), Tim Burton (*Big Fish*), and Andrew Adamson (*Shrek*), to name a few. Throughout the years, her dedication to the industry has been admired and her achievements recognized. In 2015, Alonso was an honoree of the New York Women in Film & Television's Muse Award for Outstanding Vision and Achievement. In January 2017, she received the Advanced Imaging Society's Harold Lloyd Award.

HEAD OF VISUAL DEVELOPMENT RYAN MEINERDING joined Marvel Studios in the early days of *Iron Man* and has shaped the look and feel of the Marvel Cinematic Universe from the beginning. He was integral to the visual development of such projects as *Marvel's The Avengers*, the *Iron Man* trilogy, the *Captain America* trilogy, *Avengers: Age of Ultron, Doctor Strange, Black Panther, Avengers: Infinity War, Avengers: Endgame,* the *Spider-Man: Homecoming* trilogy, *The Falcon and the Winter Soldier, Loki, What If...?, Eternals, Black Panther: Wakanda Forever,* and many more. He has held the role of Head of Visual Development since *Iron Man 3*. Meinerding studied industrial design at Notre Dame and illustration at the Art Center College of Design.

VISUAL DEVELOPMENT DIRECTOR ANDY PARK studied Art/Illustration at UCLA and at the Art Center College of Design. His career began as a comic book artist, fulfilling a childhood dream, illustrating such titles as *Tomb Raider, Excalibur,* and *Uncanny X-Men* for companies like Marvel, DC, and Image Comics, among others. After a decade in the comic book industry, he made a career switch and began working as a concept artist in video games. He was one of the leading artists designing the various worlds and fantastical characters/creatures of the award-

winning God of War video game franchise for Sony Computer Entertainment of America. Park joined Marvel Studios in 2010 as a concept artist, designing characters and keyframe illustrations for *Marvel's The Avengers*, and has worked on almost all of the Marvel Studios films since. Park was promoted to Director of Visual Development in 2015 and has led the department on *Guardians of the Galaxy: Vol. 2, Thor: Ragnarok, Ant-Man and The Wasp, Captain Marvel, Black Widow, WandaVision, Shang-Chi and the Legend of the Ten Rings, Thor: Love and Thunder, The Marvels, Ant-Man and the Wasp: Quantumania,* and *Guardians of the Galaxy: Vol. 3.*

VISUAL DEVELOPMENT SUPERVISOR RODNEY FUENTEBELLA studied design at UCLA and product design at the Art Center College of Design. Born in the Philippines and raised in San Francisco, he has worked on various projects for Electronic Arts, Atari, DreamWorks Animation, and WIRED magazine, as well as various entertainment and commercial projects. In film, he worked as a concept artist at Rhythm and Hues before joining the Visual Development team at Marvel Studios. Fuentebella has created key-art illustrations and character designs for many MCU titles, including *Captain America: The First Avenger, Marvel's The Avengers, Iron Man 3, Captain America: The Winter Soldier, Guardians of the Galaxy, Avengers: Age of Ultron, Ant-Man, Captain America: Civil War, Doctor Strange, Spider-Man: Homecoming, Avengers: Infinity War* and *Avengers: Endgame, Hawkeye, Moon Knight,* and for many upcoming MCU films and Disney+ series.

CONCEPT ILLUSTRATOR IMOGENE CHAYES is a Bay Area-based concept artist currently working on mainstream film and television projects nationally and abroad. In addition to working with Marvel Studios Visual Development on projects like *Hawkeye* and *She-Hulk: Attorney at Law,* she has worked on productions such as *Masters of the Universe, Agents of S.H.I.E.L.D., The Meg, The Orville, Terminator: Dark Fate,* a *Game of Thrones* prequel, and the film adaptation of the video game *Uncharted.* Imogene grew up in Sonoma County and began her career after graduating from the Fashion Institute of Design and Merchandising with a degree in Film and TV Costume Design. Imogene has managed to remain focused on the costume design world through concept art, and has since been very fortunate to have the opportunity to contribute her knowledge of costume design and construction, and skills in digital rendering, to the most exciting projects in Hollywood.

CONCEPT ILLUSTRATOR KEITH CHRISTENSEN was born and raised in the northwest suburbs of Chicago and has been drawing odd things from a young age. After spending four years in art school, he moved to Los Angeles in 1997 to begin his true art education: working in creature/make-up effects shops. Since then, he has carved out a niche for himself as a costume/character/prop designer with a background in practical fabrication. Today, with the support of his beautiful wife and daughter, he somehow manages to make a living conceptualizing for film and television. His credits include *Man of Steel, Star Wars: The Force Awakens, Dunkirk, Dune,* and *Avatar 2,* and at Marvel Studios, his work can be seen in *Black Panther, Moon Knight, Doctor Strange in the Multiverse of Madness,* and more.

CONCEPT ILLUSTRATOR WESLEY BURT hails from a background in traditional art and design, from drawing characters and creatures from his imagination as a child to majoring in drawing, painting, and printmaking at The Cleveland Institute of Art. He started working professionally as an illustrator and concept artist in 2001 and has contributed to numerous video game titles, toys, and TV/film projects, including *Fallout 3, Fallout: New Vegas, Batman: Arkham Origins, Silent Hill, League of Legends, Magic: The Gathering, Lord of the Rings: Shadow of Mordor, The Sims 4,* and more. He began working on film productions with the *Transformers* franchise and *The Last Knight,* as well as *Teenage Mutant Ninja Turtles: Out of the Shadows,* the *G.I. Joe* franchise, and *Dungeons and Dragons.* He has worked primarily with Marvel Studios as a visual development artist since 2016, on *Doctor Strange, Black Panther, Avengers: Infinity War, Avengers: Endgame, Eternals, Loki, Hawkeye, Black Panther: Wakanda Forever, She-Hulk,* and more.

CONCEPT ILLUSTRATOR ANTHONY FRANCISCO has contributed to Marvel Studios' visual development team on many projects, including the *Guardians of the Galaxy* trilogy, *Thor: Ragnarok, Captain Marvel, Avengers: Endgame,* and *Black Panther: Wakanda Forever.* Before coming to Marvel Studios, he worked with some of the industry's top effects houses, including Stan Winston Studios, ADI, Rick Baker, and Rhythm and Hues, creating concepts for films such as Sam Raimi's *Spider-Man, Men in Black II, The Chronicles of Riddick,* and more. He has done concept work for video games, designing for *Gears of War, Guild Wars,* and *Project Offset.* Francisco also has also done illustrations for Sideshow Collectibles and *Magic: The Gathering,*

and has been an instructor at Art Center College of Design, Concept Design Academy, CGMW, and Gnomon School of Visual Effects.

CONCEPT ILLUSTRATOR ANDREW KIM started his career in video games and has worked for studios such as Sony and Naughty Dog, creating characters and environments for highly-acclaimed franchises *Bioshock, God of War,* and *Uncharted.* He has contributed to Marvel Studios as a concept illustrator for *Thor: The Dark World, Captain America: The Winter Soldier, Guardians of the Galaxy, Ant-Man,* and many more.

CONCEPT ILLUSTRATOR VANCE KOVACS has been a professional illustrator for over 25 years with a career spanning the entertainment and publishing industries. Originally a concept artist in video games in the mid '90s, he launched a freelance career as an illustrator and concept artist for publishers and film. Project credits include: *Dungeons & Dragons, Magic: the Gathering, Planet of the Apes, Batman v. Superman, The Lion King, Jungle Book,* and for Marvel Studios, *Thor, Black Panther, Werewolf by Night,* and *Moon Knight.*

CONCEPT ILLUSTRATOR ALEXANDER MANDRADJIEV has spent 15+ years working in the motion-picture industry as a cinematic illustrator. He has worked on such films as *Black Swan, Lincoln, Edge of Tomorrow, Rise of the Planet of the Apes, Dawn of the Planet of the Apes, Philip K. Dick's Electric Dreams, X-Men: First Class,* and Marvel Studios' *Doctor Strange, Spider-Man: Homecoming, Black Panther, Marvel's The Avengers, Loki,* and more. Mandradjiev is a member of the Art Directors Guild — Local 800 of the International Alliance of Theatrical and Stage Employees working in Los Angeles.

CONCEPT ILLUSTRATOR ROB McKINNON is an Art Center graduate celebrating over 20 years as a successful concept artist, contributing designs to a wide variety of projects: theme park attractions, music videos, commercials, TV shows, film pre-production concept art, and post-production visual effects. Among the over 60 motion pictures Rob has worked on, he is very proud to have teamed up with Marvel to create concepts for *Iron Man 3, Captain America: Winter Soldier, Hawkeye,* Avengers Campus at Disneyland's California Adventure, and *Guardians of the Galaxy, Vol. 3.* Rob was also fortunate to concept for Stan Lee on a Super Hero project shortly before Stan's passing. Rob's legacy continues as his two sons Rob Jr. and Andrew work in the motion picture industry as

3D artists. Rob's daughter Star Wars (her name) has graduated college as an animator/rigger. Rob currently lives in Simi Valley, California, with his wife Valerie, family, and new grandson Logan--named after the Wolverine himself.

CONCEPT ILLUSTRATOR JOSH NIZZI graduated from the University of Illinois with a degree in graphic design. He spent the next eight years working in video games as an art director, concept artist, modeler, and animator. Since then, Nizzi has been an illustrator for feature films such as the *Transformers* series and has been able to contribute to many Marvel Studios projects, including the *Avengers* and *Captain America* franchises, *The Falcon and the Winter Soldier, Black Widow,* and many more. Josh continues to develop video game projects as well as feature film work.

CONCEPT ILLUSTRATOR JACKSON SZE has worked in advertising, video games, television, and film for studios such as Lucasfilm Animation and Sony Computer Entertainment of America. Having been a Senior Illustrator at Marvel Studios for more than a decade, he now supervises Marvel Studios projects on Disney+ including *Ms. Marvel, She-Hulk: Attorney at Law,* and *Secret Invasion.* His other credits include *Star Wars: The Clone Wars,* the *Avengers* films, the *Guardians of the Galaxy* trilogy, *Black Panther, Thor: Ragnarok, Black Widow, Shang-Chi and the Legend of the Ten Rings, WandaVision, Moon Knight,* and more.

CONCEPT ILLUSTRATOR HENRIK TAMM spent a decade doing visual development and production design for animation, including *Shrek, Kung Fu Panda, Sinbad: Legend of the Seven Seas,* and *Shark Tale,* before switching to conceptual design and visual effects art direction for live action films. Tamm has contributed to *The Chronicles of Narnia* franchise, *Green Lantern, The Girl With the Dragon Tattoo, Star Trek: Beyond, Robopocalypse, The Suicide Squad,* and more. The first Marvel film he worked on was *Captain America: The First Avenger,* and he has since worked on the *Spider-Man: Homecoming* trilogy, *Black Panther, Loki, Guardians of the Galaxy Vol. 3, Hawkeye,* and more. Originally from Sweden, Henrik grew up in Tanzania, Pakistan, and Peru before moving to Los Angeles to attend Art Center College of Design. He also writes and illustrates his own children's book series *Ninja Timmy,* which has been translated into 15 languages.

⇥ artist credits ⟶

acknowledgments

Victoria Alonso
Kristy Amornkul
Alexis Auditore
Bert & Bertie
Russell Bobbitt
Rick Buoen
Wesley Burt
Imogene Chayes
Keith Christensen
Christian Cordella
Chris Cortner
Michael Crow
Louis D'Esposito
Jacinda Dolwick
John Eaves
Kevin Feige
Sofia Finamore
Anthony Francisco
Rodney Fuentebella
Richard Isanove
Andrew Kim
Vance Kovacs
Theodore Kutt
Jillian Largoza
Scott Lukowski
Alexander Mandradjiev
Tiff Mau
Rob Mckinnon
Ryan Meinerding
Michele Moen
Nikki Montes
Mark Morales
Oksana Nedavniaya
Josh Nizzi
James Oxford
Andy Park
Esad Ribić
Rich Romig
David Ross
Maya Shimoguchi
Joe Studzinski
Jackson Sze
Henrik Tamm
Rhys Thomas
Trinh Tran
AJ Vargas
Samantha Vinzon
Bojan Vucicevic
Jon Weaver
Brad Winderbaum
Rob Woodruff